ARTHUR DOVE

Watercolors and Pastels

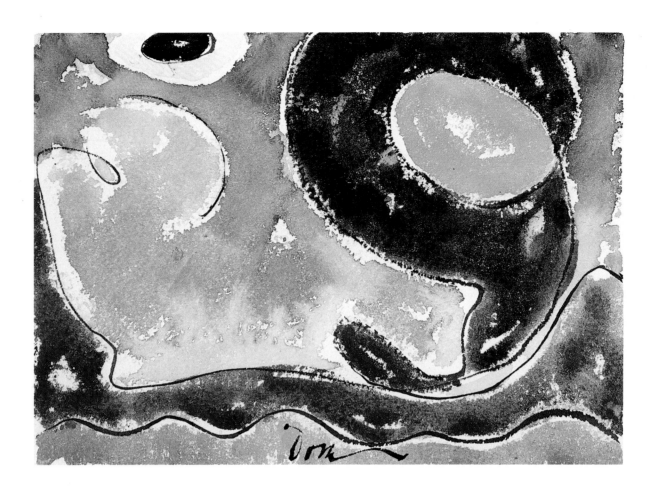

ARTHUR DOVE

Watercolors and Pastels

Melanie Kirschner

GEORGE BRAZILLER PUBLISHER NEW YORK

First published in 1998 by George Braziller, Inc.

For information, please address the publisher:
George Braziller, Inc.
171 Madison Avenue
New York, NY 10016

Library of Congress Cataloging in Publication Data:

Kirschner, Melanie, 1969–
 Arthur Dove : watercolors and pastels / Melanie Kirschner. —1st ed.
 p. cm.
 Includes bibliographical references.
 ISBN 0-8076-1447-5 (pbk.).
 1. Dove, Arthur Garfield, 1880–1946—Criticism and interpretation.
 I. Dove, Arthur Garfield, 1880–1946. II. Title.
 N6537.D63K57 1998
 759.13—dc21 98-29726
 CIP

Frontispiece:

Arthur Dove. *Centerport Series, No. 4.*
1941–42. Watercolor on paper, 5 x 7 in.
Herbert F. Johnson Museum of Art,
Cornell University, Ithaca, New York.

Designed by Philip Grushkin

Printed and bound in Italy

First paperback edition

Acknowledgments

I am grateful for the opportunity to thank the many people who have contributed to this project. I am indebted to Elizabeth Hutton Turner of the Phillips Collection for involving me in her 1997 exhibition of Dove's watercolors at the Phillips and for sharing her research and her thoughts about Dove's watercolors and their role in his career with me. I also owe special thanks to Howard Singerman for his insightful reading of the manuscript. Numerous museum professionals aided in my search for Dove's watercolors and generously provided photography and leads. The librarians and staff at the Fiske Kimball Library at the University of Virginia and the Virginia Museum of Fine Arts Library have been vastly helpful. I am also grateful to Elsa Mezvinsky Smithgall and Karen Schneider, both at the Phillips Collection. This book would not exist without the vision of George Braziller and the tireless efforts of Mary Taveras. I must also thank Adrienne Baxter for her sensitive editing.

I have had the privilege of studying with the distinguished faculty of the University of Virginia and Tufts University. I will always owe a debt to Roger B. Stein, Lydia Csató Gasman, Howard Singerman, and Margaret Henderson Floyd for sharing their knowledge, vision, and devotion to scholarship.

I could not overestimate the value of support from my friends and family. In particular, I would like to thank Nancy, David, and Susan Perlstein for their enthusiasm, and Madeline Logee and Bea and Jerry Casner for their hospitality. No one outshines my sister, Cindy Kirschner, for her support and encouragement. Of course, my parents, Roberta and Bill Kirschner, deserve the greatest thanks, for all their grand deeds and small gestures. My husband, Steven Perlstein, adapted graciously to sharing his new wife with a book project. His limitless kindnesses and contributions made him an essential partner in this endeavor. My grandparents, Alice and Samuel Paull, Heda Kirschner, and the late William Kirschner have been a constant source of love and inspiration. This book is dedicated to them.

Contents

ARTHUR DOVE

Watercolors and Pastels

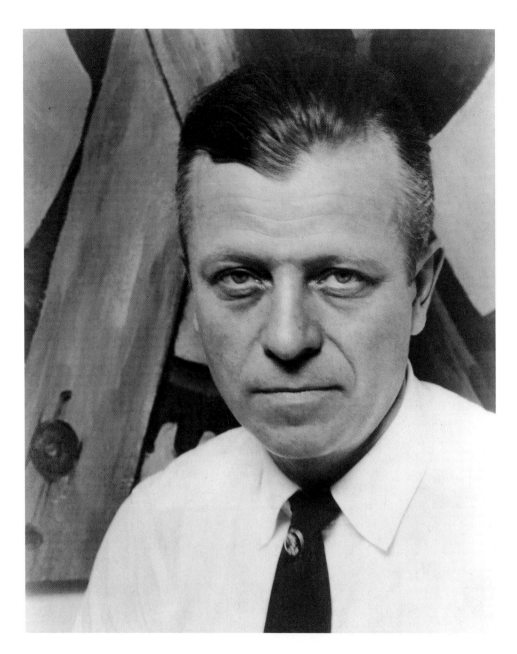

Figure 1. Alfred Stieglitz. *Arthur G. Dove*.
1922. Gelatin-silver print, 9 3/8 x 7 1/2 in.
Philadelphia Museum of Art

I do not see why photography, water colors, oils, sculptures, drawings, prints . . . are not of equal potential value. I can not see why one should differentiate between so-called "major" and "minor" media. I have refused so to differentiate in all the exhibitions that I have ever held. . . . It is the spirit of the thing that is important.

—ALFRED STIEGLITZ[1]

THE PASTELS AND WATERCOLORS that Arthur Garfield Dove exhibited at Alfred Stieglitz's New York galleries between 1912 and 1946 are among the purest and most lyrical statements of his career. They record the initial sealing of his intimate relationship with the American landscape, his constant subject matter, and document his fresh approach to painting that landscape every day. Like the other artists whom Stieglitz showed at his galleries—Georgia O'Keeffe, John Marin, Marsden Hartley, and Charles Demuth among them—Dove (1880–1946) was at the forefront of American modernism in the 1910s and 1920s, seeking a distinctly American, modern expression and finding his subject matter in the American landscape.

Dove's was consistently the most abstract work created by the artists around Stieglitz, making him perhaps the least understood of the circle in his own time and the most relevant to succeeding decades. Dove's style continued to evolve until his death, as he responded to the advances of the most progressive artists in the United States and abroad and integrated new ideas in his constant drive to clarify his own work. Dove's pastels of the 1910s and 1920s and his watercolors of the late 1920s and the 1930s and 1940s often explored his major stylistic shifts, including his breakthrough into abstraction, before similar tendancies appeared in his oil paintings. In addition to his focus on finding new reconciliations of the natural world with abstract expression, Dove was perpetually interested in the potential formal effects of different media. Pastels and watercolors were

11

essential tools in both of these explorations. Viewing these works both within the context of the revivals of pastel and watercolor in America in the first half of the twentieth century, and as integral components of Dove's oeuvre, reveals the richness of his artistic achievement.

The group of pastels that came to be called *The Ten Commandments* (plates 1–3, 5) was Dove's first major exhibited work. Shown in New York and Chicago in 1912, these works startled and perplexed critics and the public with their almost fully abstract representations of the "essence" of the landscape. In hindsight, the nonrepresentational, allover patterning of these pastels, so difficult for his contemporaries to understand, positions them as harbingers of the flourishing of American abstraction in later decades. Dove's modern reputation as the first American artist to achieve total abstraction rests on *The Ten Commandments*, that is, on pastels. While Dove returned to more traditional landscape imagery in the following years, the rhythmic forms and soft surface texture of the pastels continued to exert a strong shaping influence on his work throughout the 1910s and 1920s. Again in hindsight, they establish his willingness, from the beginning of his artistic career, to work out serious questions in mediums other than oil paint.

Watercolors were a central component of Dove's artistic development and artistic expression between 1928 and his death in 1946. In these last two decades of his career, Dove produced dozens of watercolors each year and, after 1933, worked almost exclusively on paper in the spring and summer months. In the cooler months Dove selected compositions from the summer's stash of watercolors to enlarge into full-size works. Serving as preliminary studies for Dove's larger paintings in oil, wax emulsion, or tempera, his watercolors and other small works on paper reveal the artist's initial, spontaneous response to nature and his original conceptions of the ideas and compositions that would later appear in his larger paintings. The stylistic diversity of the watercolors reveals the extent of Dove's receptivity to the ideas of the most avant-garde American and European artists in the 1930s and 1940s, as he experimented with new ideas on paper before committing them, in his own style, to canvas. In addition to their centrality to his own artistic development, Dove's pastels and watercolors were important contributions to the revivals of those mediums for serious artistic work in the United States in the first half of the twentieth century.

Dove began his artistic career as a commercial illustrator after graduating from Cornell University in 1903.[2] At Cornell he had switched from a prelaw concentration to one in drawing. This was Dove's only formal art training. He was successful as an illustrator in New York City, working for magazines like *Harper's* and *The Saturday Evening Post* and doing some illustrations for books. He socialized with other illustrators, among them the artist John Sloan. His artistic ambition quickly surpassed illustration, and in 1907 he and his wife, Florence Dorsey, left for Europe. They spent a year and a half in France, largely in the countryside, away from the main artistic centers. Dove's painting in France was shaped by Impressionism and Fauvism, introduced to him primarily by his American colleagues abroad, such as Max Weber and Alfred Maurer. He returned to the United States in 1909, leaving one painting, *The Lobster*, a Fauvist still life, to be exhibited in the Salon d'Automne. In 1910 this painting became the first work Dove exhibited at Alfred Stieglitz's Little Gallery of the Photo-Seccession, commonly known as "291," its street number on Fifth Avenue, when Stieglitz included him in his "Younger American Painters" exhibit. This began a friendship between the two men that continued until Stieglitz's death, just months before Dove's.

Stieglitz was a constant presence in Dove's life. While the two rarely lived in the same city, they exchanged letters frequently. These provide an invaluable window into their ongoing dialogue about their art and their lives. Even when Dove had little new work to show between 1913 and the early 1920s, Stieglitz remained encouraging, and after 1926, Dove could count on an annual one-man exhibition at Stieglitz's gallery. Following the demise of 291 in 1917, Stieglitz ran The Intimate Gallery from 1925 to 1929, and An American Place from 1930 until his death. Stieglitz's unequivocal support for Dove's art provided not only a constant schedule for each year, geared to a show in the early spring, and an outlet for sales, but most important, the reassurance of being understood, admired, and defended by a respected colleague. Dove had many artist friends; Stieglitz was the most constant. Dove's ideals and his art in many ways paralleled those of Stiegliz and the other artists whom he exhibited regularly at his galleries.

Dove, Stieglitz, and the other American artists who began to gather around 291 in the 1910s were concerned with a twofold problem: modernism and the creation of a

distinctly American painting, freed from its persistent reputation as a poor imitation of European art. The common mission of those Americans who gathered at 291 after 1910 to forge an independent modern art was part of a larger cultural movement in all of the arts. Artists, writers, and cultural critics in the first two decades of the twentieth century desired to create something wholly new, expressive of the vibrancy of America and unsullied by Europe and its cultural baggage. While some artists of these years saw the life of the modern city and its technology as the most appropriate representatives of America, Dove, like many other artists, found his connection to America through the physical earth. The land and the landscape had been a constant factor both in American art and in the American consciousness since the colonial era. The artists of Dove's generation saw their American predecessors in Walt Whitman, Henry David Thoreau, and Ralph Waldo Emerson, who each had an intense connection to the American landscape.[3]

One problem for the visual artists was the creation of an American style, or at least the creation of an individual style that was not an obvious distillation of a European style. As American artists, including those of 291, sought to create an art that expressed the independent, vigorous American character and the vitality of modern life, they rejected the simple literalism of depicting New York City skyscrapers or the Maine coast in favor of an art that was American in style as well as in subject. While they eschewed imitation of European styles, the theories of the French psychologist Henri Bergson, the Russian-born German artist Wassily Kandinsky, and to a lesser extent Pablo Picasso and Georges Braque pointed the Americans in the direction of abstraction from nature. Bergson's idea that the artist used intuition to place himself in sympathy with the object and break down the space between it and himself[4] may have reinforced Dove's intimate approach to nature. Bergson's 1907 book *Creative Evolution*, translated in 1911, was widely read in the United States. Surely it provided critics and viewers with the inclination to understand and discuss Dove's work as an expression of Bergsonian ideals. Another European who was of particular importance to Dove was Kandinsky. Dove, like others of his contemporaries, read Kandinsky's *Concerning the Spiritual in Art*, in the original German, published in 1911 as *Über das Geistige in der Kunst*, suggesting that he felt it too important to wait for publication of the 1914 English translation.[5] Kandinsky's

emphasis on the importance of form and color as expressive components of art that at their best produced "vibrations in the soul" of the viewer and his stress on music as a model for pure expression were important ideas for Dove. These ideas of the Europeans and of the American artists around 291 were disseminated to the group through Stieglitz's magazine, *Camera Work*, published between 1903 and 1917. Initially devoted to photography, *Camera Work* from 1909 until its demise increasingly focused on the ideas of modern art, publishing extracts from longer writings or essays by Bergson, Kandinsky, Francis Picabia, and Gertrude Stein, original articles by the critics Charles Caffin and Sadakichi Hartmann, and reprints of reviews of 291 exhibitions. *Camera Work* also published statements and essays by the artists exhibited at 291. Max Weber, Marsden Hartley, and the Mexican caricaturist and art dealer Marius de Zayas all found outlets for their writing in the pages of Stieglitz's magazine. *Camera Work* also published photographs of a selection of the works from most shows at 291, providing its artist subscribers with the most timely reproductions of the latest European and American art. The magazine was instrumental in introducing American artists to a wide range of modernist ideas and visual forms. While Dove was living outside New York City, in Westport, Connecticut, from 1910 to 1920, *Camera Work* was an important part of his ongoing connection to his peers and the artistic issues they were addressing.

Dove's son, William, was born in 1910, and that year the Doves moved to a farm in Westport, but the painter was in no way artistically isolated there. Dove had hoped to be able to support his family from the farm alone but found it necessary to continue doing some illustrating work. He went into the city often to look for illustrating jobs and to view the latest shows, and Westport was a popular retreat for artists and writers from New York in the 1910s and 1920s. While in Connecticut, Dove socialized with critic and writer Van Wyck Brooks, writer Sherwood Anderson, and photographer Paul Strand. However, farming and illustrating left him relatively little time for his art, and after *The Ten Commandments* he produced only a few works in charcoal, pastel, or oil each year until the early 1920s. In 1920 Dove left both Westport and his wife and moved onto a boat in the waters around New York with the artist Helen "Reds" Torr. While Dove supplemented his income with illustrating jobs until 1930, his departure from Westport signaled a return to more or less full-time artmaking.

Dove's paintings of the early 1920s are characterized by limited color schemes, organic, nature-based abstraction, and rhythmic compositions of repeating forms. Works such as *After the Storm, Silver and Green (Vault Sky)*, c. 1923 (figure 2), demonstrate that while these images retained the restriction of color and the repeating curves that originated as important components of Dove's work in the pastels of 1911–12, they could also contain the natural space of traditional landscape compositions. His subject matter, as always rooted in the natural world, turned to the sea and the harbor that surrounded him. The cows that were the inspiration for some of his early pastels disappeared temporarily and were replaced with dramatic thunderstorms over the ocean and the machinery of a busy harbor. In these years Dove began experimenting with the addition of metallic paints to his palette. While pastel had been a traditional artists' material, metallic paint remained an industrial medium at that time. Dove did not use it to depict machinery, however, but for natural elements: lighting, stars, waves, and clouds. These metallic paints were as different from oil in the way they reflected light as pastel had been, giving the images a soft sparkle Dove could not have achieved with standard oil paints.

Dove's use of metallic paint in some of his works of the early 1920s may be considered his first step toward the incorporation of a variety of natural and man-made materials in his assemblages of the following few years. The period from 1925 to 1927 marked a time of artistic upheaval for Dove, one in which he produced only a few oils and pastels while creating assemblages inspired by Dada and Cubist collage. Incorporating sandpaper, newspaper, wire mesh, shells, and even a glass lens, in addition to paint, Dove's assembled portraits, landscapes, and non-objective compositions are his most emphatic expression of a desire to expand his artistic vocabulary beyond the physical limitations imposed by oil paint.[6] This turn to collage was brief, and Dove provided no explanation either for his adoption of collage or for his switch to painting in oil and watercolor as a primary outlet of artistic expression in 1927.

In Dove's painting of 1927 his previous focus on the repetition of curves and angles largely vanished. His paintings and pastels of the late 1920s are more fluid and organic, looking back in his own work to some of *The Ten Commandments* (plates 1–3, 5) and to his 1917 pastel *Sentimental Music* (plate 4). This shift from geometric fracturings of space

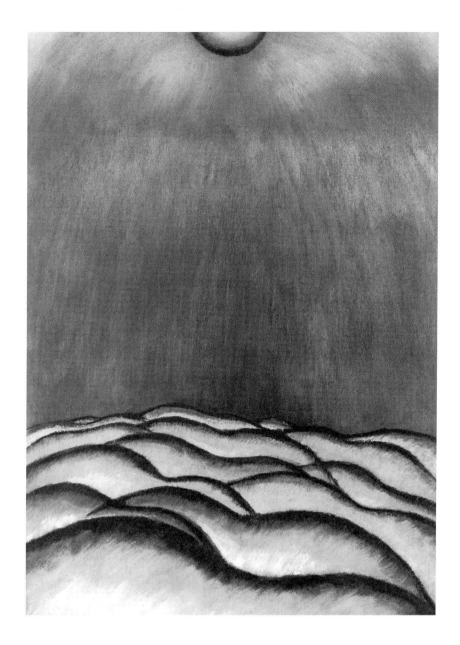

Figure 2. Arthur Dove. *After the Storm, Silver and Green (Vault Sky).* c. 1923. Oil and metallic paint on wood panel, 24 x 18 in. New Jersey State Museum, Trenton

to a seemingly more intuitive treatment may signal a larger shift in his artistic orientation away from Cubism toward other manifestations of European modernism: Surrealism and the Expressionism of Kandinsky. Dove's turn away from his collage method of the mid-1920s also suggests a refocusing of his interests. While Dove kept current with developments in European art, he adapted ideas from others selectively and deliberately, choosing to explore ideas and formal innovations that furthered preexisting

directions in his own work. It was at this time, in 1927 or 1928, that Dove began to make preliminary studies in watercolor for his larger paintings in oil or other heavier mediums. From Dove's earliest watercolors, such as *Distraction*, 1928 (plate 6), to those done in the last years of his life, such as *Untitled Sketch (Study for Green and Brown)*, 1945 (plate 7), he used works on paper to experiment with design, composition, color, and style before committing to a large canvas.

In 1933, following the death of his mother, Dove and Torr moved to a family farm in his hometown of Geneva, New York, to dispose of the highly mortgaged family properties. While Dove had begun working in watercolor in the late 1920s on the North Shore of Long Island, it was in Geneva that watercolor became an essential part of his working process and painting schedule.[7] Dove's work of the mid to late 1930s delved deeply into the landscape of Geneva, and interpreted it through an expressive abstraction. In this decade, Dove also carefully worked through the influences of Purism, Surrealism, and Neo-Plasticism in his watercolors and sketches, integrating new ideas into his own artistic vocabulary when they could advance his distilled interpretation of the landscape. The dynamic, irregular grid of the watercolor *Swinging in the Park*, 1930 (plate 8), a work Dove chose to enlarge in an oil painting, uses a Cubist, even Futurist, vocabulary to convey motion in the landscape. *Untitled*, n.d. (plate 9), suggests the automatism of André Masson and Joan Miró in its linear abstraction, while *Barns*, 1935 (plate 10), is a more purely geometrical, reductive work. These watercolors all reveal Dove experimenting with different ways of visually representing his relationship to the landscape on paper, before translating these motifs to large paintings on canvas or board.

While geographically removed from the art centers of Paris and New York City for most of his life, Dove consistently strove to stay abreast of the latest ideas and formal developments, aware of the artistic currents around him while preserving the independence of his own vision. To this end, Dove and Torr read copiously. The transcendentalism of Emerson and Thoreau, Whitman's call for an intrinsically American expression, and the works of Bergson and Kandinsky had all been early reading. In later years they received copies of the French art journal *Cahiers d'art*, which was weighted toward Cubism in its coverage, and of *Transitions*, which focused on artists of a more Surrealist bent. Dove was consistently willing to track down writings by artists

who had sparked his interest, even if it meant tedious translation work. Dove and Torr also made a point of visiting the museum shows and gallery exhibitions of the latest work when they could make the often strenuous trip into Manhattan. In 1936 Dove and Torr visited Alfred H. Barr's "Cubism and Abstract Art" exhibition at the Museum of Modern Art in New York, and A. E. Gallatin's Gallery of Living Art at New York University. Between the two Dove would have seen work by Picasso, Braque, Fernand Léger, Miró, Masson, Piet Mondrian, and numerous other avant-garde European artists. Friends and relatives helped them stay current by forwarding magazines, books, and exhibition catalogs.

Dove's most significant patrons and primary financial supporters during these years were Duncan and Marjorie Phillips, who exchanged an annual stipend for first choice of several paintings from Dove's yearly exhibition.[8] Despite the Phillips's support, small-town life in Geneva and the struggle to make the family's properties cover their own expenses during the Great Depression eventually became an enormous mental and physical strain. Dove and Torr decided to move back to Long Island in 1938, just before Dove's health began to fail. The old one-room post office that they bought in Centerport became Dove's window on the world for the rest of his career. Located on the edge of the water, the house in Centerport allowed Dove to paint and sketch his favorite subject, the marine landscape, from his porch or even his bed. The format of watercolors and sketches, which permitted him to work outside more easily, was essential in Centerport because it allowed him to continue working when he wasn't able to stand at an easel.[9] The move to Centerport also coincided with a change in Dove's style. In Centerport the organic, undulating line, and soft shading of his work of the 1930s solidified into a more rigorous, flat geometry. Dove's paintings of the 1940s are seemingly less concerned with exploring the landscape than with exploring painting itself as an abstract language of form and color, and are thus often closer to complete abstraction than any of his previous works. Dove's watercolors and small wax emulsion and tempera sketches of these years, such as *Out of the Window*, 1940 (plate 11), and *Arrangement from Landscape*, 1941 (plate 12), reveal both where the artist wanted to go with his art and how he perceived its past, as he reworked past motifs and incorporated them into his new visual language.[10]

Pastel and Watercolor Revivals in the United States

Dove was not alone among American modernists in exploring the creative properties of pastel and watercolor as significant mediums. The early twentieth century witnessed a flourishing of both mediums at the hands of traditional and progressive artists of Europe and America, and both were well established by the time Dove made his contributions to their development.[11] For much of the nineteenth century, pastel and watercolor had been considered "secondary mediums," fit only for studies or amateurs. However, beginning in the 1870s in France and the United States, both pastel and watercolor gained the renewed appreciation of progressive artists and, as a result, slowly gained acceptance by critics and the public as serious artistic mediums. Pastel thrived in the first two decades of the twentieth century, while watercolor witnessed a revival in the 1920s. By 1928 when Dove began to use watercolor regularly, the watercolors of avant-garde artists such as Georgia O'Keeffe, John Marin, and Charles Demuth had established the legitimacy of the medium for serious art and created a critical perception of watercolor as a medium particularly well suited to the vigorous expression of the American artist. Dove must have seen his work in pastel and watercolor in part within these revivals, as participating in a common endeavor to broaden the acceptable materials for high art and locate them in the freedom of American art.

Pastel and watercolor had begun their inroads back into high artistic practice with the work of J. M. W. Turner in the first half of the nineteenth century. The French Impressionists' affinity for the pure colors of pastel secured the reascendance of that medium. James Abbott McNeill Whistler, Édouard Manet, Eugène Boudin, Edgar Degas, Mary Cassatt, and Claude Monet were among the artists who did serious pastels in the 1870s and 1880s. Surely the practicality of pastel and watercolor for working *en plein air* appealed to this group of artists. Many of these artists were eagerly collected by Americans after the late 1890s, perhaps contributing to the growing popularity of pastel in the United States at the end of the nineteenth century. They were followed into the medium by Henri de Toulouse-Lautrec and Odilon Redon, whose work would be singled out for admiration by the first generation of American modernists. American artists

typically adopted pastel slightly later than did the French. However, by 1882 enough American artists, primarily those now known as the American Impressionists, were proficient in the medium to suggest the need for an organized exhibiting group. The Society of Painters in Pastel was founded in 1882 by William Merritt Chase and others.[12] As pastel gained adherents, American watercolor painting was already well on its way to dominance, most visibly in the work of the American artists Winslow Homer, John La Farge, and John Singer Sargent. This allowed the two mediums to press the legitimacy of works on paper in tandem, as pastels were included in watercolor shows. The American Society of Painters in Water Color had been established earlier, in 1866, and was renamed the American Watercolor Society in 1877.[13] Its exhibitions were popular with critics and the public and often achieved substantial sales. While the Society of Painters in Pastel ceased to exhibit after 1890, it had been critically well received, and the exhibition of pastels simply moved into watercolor shows and individual exhibitions.[14] Both mediums were appreciated for their potential to create either an irregular texture that used revealed paper as a component of each stroke, or a highly finished, smooth surface, and allowed the artist to express his subject quickly and freely or in a more deliberate, precise manner. Pastel and watercolor were increasingly visible on the American art scene at the end of the nineteenth century, well positioned to claim further respect in the twentieth.

The fondness of the American Impressionists for pastel was passed on to the next generation of American artists, in large part through the teaching of Chase at the Art Students League in New York City and the Pennsylvania Academy of the Fine Arts in Philadelphia, and of Thomas Anshutz and Hugh Beckwith, other popular instructors at the Pennsylvania Academy of the Fine Arts.[15] The use of pastel as a medium transcended the social and artistic divisions of the American art scene in the 1910s and 1920s. Robert Henri, Arthur B. Carles, Arthur B. Davies, Preston Dickinson, Joseph Stella, and Abraham Walkowitz were among the artists who did serious pastels at various points in their careers. The illustrators who later exhibited as The Eight, such as Everett Shinn, John Sloan, and William J. Glackens, found that pastel was ideal for adding tonal value to their illustrations and later used it in their non-illustrational work.[16] All the artists closely connected with 291 worked in pastel at some point in their careers.

While Dove may have become acquainted with pastel in his drawing classes at Cornell, he would certainly have been aware of its professional use by the artist-illustrators with whom he socialized in New York prior to his trip abroad in 1908. He was well-acquainted with the members of The Eight, especially Sloan. American artists who traveled abroad at the beginning of the twentieth century were exposed to all aspects of European experimentation with the "secondary media" in exhibitions, visits to artists' studios, and classes. While relatively little is known of Dove's travels in France, he most likely attended the Salon d'Automne of 1908 as he exhibited a painting there. He may also have seen Odilon Redon's pastels, twenty-four of which were exhibited in Paris in the autumn of 1908. His closest American friend in France, Alfred Maurer, executed pastels throughout his brief career and may have encouraged Dove's exploration of the medium.

Stieglitz certainly would not have discouraged Dove's interest in pastel. Twenty pastels were included in John Marin's 1910 one-man debut at 291, and works on paper had dominated Stieglitz's shows of the European modernists between 1910 and 1913. The artists around 291 continued to experiment with pastel well into the 1910s and 1920s. Max Weber focused on pastels between 1912 and 1916, perhaps encouraged to continue working in the medium in part by Dove's 1912 show. Hartley found pastel particularly suitable for his representations of the New Mexico landscape in 1919 and continued to use it sporadically thereafter.[17] O'Keeffe used pastel as a softer alternative to oil, taking advantage of the precision of its application without altering the style she achieved in her oils. O'Keeffe had been impressed at the beginning of her career by a color reproduction of Dove's pastel *Based on Leaf Forms and Spaces*, one of *The Ten Commandments*, which she saw in Arthur Jerome Eddy's 1914 book *Cubists and Post-Impressionism*, just before she began her own series of charcoals in 1915.

Dove's foray into pastel was immediately preceded in January 1911 by the first exhibition of a new artists' organization, the Pastellists, at the Folsom Galleries in New York. Most of the twenty-three artists whose work was shown were contemporary Americans. George Wesley Bellows, Arthur B. Davies, Thomas Wilmer Dewing, Walt Kuhn, Everett Shinn, and J. Alden Weir were among the participants.[18] The show of sixty-seven works was well reviewed in art journals and in *The New York Times*.[19] While

we cannot be certain whether or not Dove attended the Pastellists exhibition, some of the critics and general audience who later attended his show surely did. The Pastellists held their second exhibition in December 1911. Clearly Dove's 1911–12 pastels were executed during a period of heightened artistic and public awareness of the medium. Dove's *The Ten Commandments* grew out of and contributed to this renewed interest in pastel. By the time this series was exhibited in 1912, the heightened receptivity of the time allowed critics to address the pastels as serious, major works. The fact that they were pastels may actually have made their radical, abstract nature more approachable for some critics. Even when the artworks were not appreciated for their abstraction, they were often praised for the richness of their pastel surfaces. While Dove continued to use pastel throughout the 1920s, the medium generally declined in popularity for both artists and the public after 1920.

In the 1920s, watercolor claimed the title of the ascendant American medium. In the first decades of the new century, the continuing popularity of Homer's watercolors, the ongoing visibility of Maurice Prendergast, and some much publicized sales of watercolors by John Singer Sargent and Homer to the Metropolitan Museum of Art, the Brooklyn Museum, and the Museum of Fine Arts, Boston, served as constant reminders of a strong American tradition in watercolor. By 1910 New York, Boston, and Philadelphia all had annually exhibiting watercolor societies, dominated by traditional, academic artists but open to the occasional incursions of more experimental ones. These shows were widely attended and reviewed. Several important exhibitions at 291 introduced American critics and gallery-goers to the modernist watercolors of prominent European artists and stressed the significance of the medium for American artists who might already have been exposed to these works in France. While European artists of the nineteenth and twentieth centuries had consistently done some work in watercolor, particularly in later years, there was no European tradition of artists creating a significant body of work in watercolor. Artists, critics, and the art-going public were primed to accept watercolor as a medium in which American artists could break free of European influence and assert their own traditions.[20]

Modernist watercolor arrived in this country from Europe sometime between 1908 and 1910. Marilyn Kushner has proposed that the 291 exhibition in 1910 of Paul

Cézanne's watercolors was the critical moment for American modernist watercolor.[21] With their abundant revealed paper and abbreviated suggestions of form, Cézanne's watercolors were the most avant-garde to be shown in this country to that point. Many of the artists who visited the show had had the opportunity to see these works in Paris at the 1907 Cézanne retrospective at the Salon d'Automne and responded sympathetically. American critics and collectors, however, remained bewildered by the Cézanne show in 1910 and showed little interest in his watercolors until they were shown again in 1916 at the Montross Gallery.[22] The Cézanne show alone may not have been the sole inspiration for the flourishing of watercolor that occurred in the United States after 1910. However, it was a key moment in a larger series of exhibitions of European and American modernist watercolor. The Cézanne show was preceded at 291 by an exhibit of Henri Matisse's lithographs, drawings, watercolors, etchings, and one oil, in early 1908. John Marin's show of watercolors hung at 291 in April 1909. These shows had been enthusiastically received by the press and were followed by additional Matisse and Marin exhibits prior to the Cézanne show. An exhibition of Rodin drawings and watercolors hung at 291 in April 1910. The Cézanne show was immediately followed by a show of Picasso's drawings and watercolors.[23] Together with the revelation of Cézanne's watercolor technique, these exhibitions firmly declared the legitimacy of watercolor as a medium of modernism. America's watercolor tradition declared it a medium in which American artists could build on an indigenous history and lay claim to national superiority.[24]

While the oil paintings included in the Armory Show in 1913 corrected this watercolored view of European modernism, watercolors were given the spotlight again with a much publicized exhibition at 291 immediately following the Armory Show in March 1913. It showed sixteen "studies" of New York, predominantly watercolors, by Francis Picabia. Dove had been living in Westport since 1910 and visited the city when he could, but his precise visits to 291 are largely unrecorded. His presence at the Picabia exhibit, however, was documented by a *New York Sun* reporter, who relayed that "while Mr. Dove was looking at Picabia's cryptograms the Frenchman was confronted without warning with what Dove . . . had done. Recognition followed as quickly as though two persons born with strawberry marks upon their arms had suddenly discovered the fact."[25]

Clearly, by 1913 Dove was aware of artists pursuing similar stylistic goals in watercolor, but chose not to explore the medium himself for another fifteen years.

Still, modernist watercolor blossomed in the United States in the 1910s and 1920s. By 1921, watercolor was so common a medium for American artists that the Brooklyn Museum of Art was able to hold "A Group Exhibition of Watercolor Paintings by American Artists,"[26] the first retrospective exhibition of American watercolor that reached beyond the members of the American Watercolor Society to a broader group that included modern and academic artists. While many advanced artists were not included, one reviewer was able to find enough of merit in the show to declare, "The painting of Winslow Homer, Charles Demuth and John Marin stands as a challenge and a realization. More than that, it is an affirmation that a truly indigenous expression is as possible in America as in Europe."[27] That same year A. E. Gallatin, on his way to becoming an important collector of modern art, published *American Water-Colourists*, the first book on the subject.[28] Charles Burchfield, Oscar Bluemner, Charles Demuth, Edward Hopper, John Marin, Joseph Stella, and Abraham Walkowitz are among the artists who were noted for their watercolors in these decades. Even Stuart Davis exhibited five watercolors in the Armory Show. By 1930 the Newark Museum's "Modern American Water Colors" exhibition contained works by 107 artists, and the catalog boasted that "the best American water colorists have no superiors in the world today."[29] Clearly, American artists and critics had embraced watercolor as a medium whose fluidity and speed made it particularly appropriate for modernist experiment and for the expression of the vitality of twentieth-century America, a nation in constant pursuit of speed in its technology, its growth, and its lifestyle.

Dove had been concerned from the beginning of his career with finding an identity for American art that went beyond subject matter in its expression of America, proposing the following:

> When a man paints the El, a 1740 house or a miner's shack, he is likely to be
> called by his critics, American. . . . What do we call "American" outside of
> painting? Inventiveness, restlessness, speed, change. Well, then a painter may put
> all these qualities in a still life or an abstraction, and be going more native than
> another who sits quietly copying a skyscraper.[30]

Watercolor's critical acclaim as a distinctly American artistic medium, a visual embodiment of the restlessness and dynamism that typified modern American life, undoubtedly contributed to Dove's embrace of the medium. Surely this aspect of watercolor's use appealed to Dove ideologically as well as practically. It is only surprising that he did not incorporate watercolor into his work earlier than 1928.

More than a decade earlier, John Marin had become the first American to base his reputation on an original, abstracting watercolor style more indebted to the modernism of Cubism and Futurism than to the Post-Impressionism that was a common source for earlier American watercolorists. Another of Stieglitz's closest associates, Marin began exhibiting at 291 around the same time as Dove, although he showed with more regularity during the 1910s and 1920s. His work was consistently well received by the public and critics, much more so than Dove's, and he was another favorite of Duncan Phillips's. His watercolor style, indebted to Whistler and Cézanne, was radical for an American in leaving vast quantities of untouched paper and exploiting the so-called remainders, specks of revealed paper, left by the use of a dry brush on textured paper. In works like *Lower Manhattan*, 1920 (figure 3), Marin used line aggressively—both the slash of watercolor and the drawn line—allowing it to remain independent of form and so expressing the forces of movement and change. Dove and Marin appreciated each other's work. Dove could not have ventured into watercolor without an awareness of Marin's approach to the medium.

Of the significant contributors to the American watercolor movement, the artist who would come to be artistically and personally closest to Dove in the late 1910s and 1920s was Georgia O'Keeffe. Like Dove, O'Keeffe's first mature expressions were works on paper, in her case charcoals and watercolors rather than pastels. She used the languid flow of watercolor, each color seemingly applied in a single brushstoke, to create images that seem to evoke nature through their own organic existence and resist categorization under one of the European modern styles.[31] She did, however, have a copy of the issue of the 1911 *Camera Work* that reproduced some works from the exhibition of Rodin drawings and watercolors at 291, and the influence of the Rodins on her figural watercolors is one of the few clear instances of European influence on her work.[32] O'Keeffe did watercolors for only a comparatively brief period, concentrating on them in 1916 and 1917, executing only a few into the early 1920s, and turning to other mediums long before Dove began

his exploration of watercolor. Her work was available to Dove through Stieglitz, however, and Dove and O'Keeffe also exchanged letters and visits.

The revivals of pastel and watercolor in the United States provide a context for Dove's work, connecting him to a movement that was larger than the small circle of artists around Stieglitz. While Dove always exploited the particular characteristics of each medium to suit his own individual expressive and formal goals, he would have been

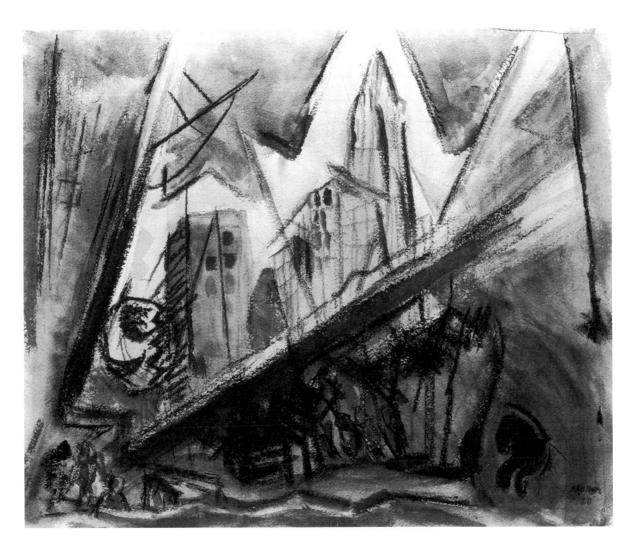

Figure 3. John Marin. *Lower Manhattan.*
1920. Watercolor and charcoal on paper, 21 $^7/_8$ x 26 $^3/_4$ in.
Museum of Modern Art, New York

aware that merely working in those mediums was a statement of allegiance to certain ideas. The revival of pastel arose primarily from the democratic notion of equality of mediums and a renewed perception of the formal potential of the medium. The ideology behind the proliferation of American watercolors in the 1920s, on the other hand, added to these concerns a more nationalistic claim of the intrinsic ability of the American artist to use watercolor as it ought to be used, with speed and dash. This conception was clearly sympathetic with Dove's desire for the creation of a distinctly American art and must have affected his decision to pick up the medium.

Pastels

When Dove returned from a year and a half in France in 1909, he retreated to the woods of his native Geneva, New York, for about a month and in 1909 or 1910 executed six small oil paintings, which were never exhibited in his lifetime. While dramatically abstracted, these works retained recognizable references to the landscape, his subject matter for the rest of his career. *The Ten Commandments* and other similiar pastels constituted his next step toward abstraction. It is unknown why the ten pastels that were exhibited at Stieglitz's gallery, 291, and at the Thurber Gallery in Chicago in 1912 were given this group title, or when it was attached to the series. Most likely Stieglitz or Dove thought to unify the obviously stylistically and conceptually related group with a series title. Which of Dove's 1911–12 pastels constituted *The Ten Commandments* was also unrecorded at the time, but exhibition reviews and the artist's recollections enabled later scholars to propose a likely set. *Movement No. 1* (plate 1), *Team of Horses* (plate 2), *Nature Symbolized No. 1, Nature Symbolized No. 2* (also known as *Wind on Hillside*), *Nature Symbolized No. 3, Sails* (plate 3), *Based on Leaf Forms and Spaces* (present location unknown), *Cow* (plate 5), and *Calf*, all dated 1911–12, are generally accepted as constituting the original group.[33] In these works Dove attempted to go beyond his small oils in extracting the essence of color and form from the landscape. This resulted in images that were as close to complete abstractions as had been seen anywhere at this date.

The exhibition of these pastels was essentially Dove's first public demonstration of

his approach to the derivation of an abstract composition from the landscape. The abstraction of these works was so advanced for their time that this show, in both cities, received more critical comment than any of Dove's numerous subsequent exhibitions. *The Ten Commandments* established Dove as the most avant-garde painter in the United States at the moment—a quality that would also make his work seem inaccessible and difficult to much of the public.[34] They also fixed the baseline of Dove's personal artistic standards for surface texture and his approach to composition from the landscape. It is notable that Dove chose pastel, not oil paint, as the medium in which to explore and develop the move into abstraction. Much of his oil painting in the following years would attempt both to improve upon the lustrous surface of pastel and to mold the geometric idiom of the majority of *The Ten Commandments* into a more flexible artistic language.

Dove's 1911–12 pastels used the softness and control of the medium to smooth out the scratchy impasto of the small oils that had preceded them. Where the aggressively executed oils show signs of a struggle with the expression of the subject in paint, the pastels are coolly compliant. The heavy, almost crude black outline of the oils, perhaps remnants of Dove's recent exposure to Fauvist painting or even of his own career as an illustrator, are slimmed down and delicately incorporated into the forms of the pastels. The areas of color are gently modeled into a smooth, continuous, thick surface that capitalizes on the soft texture of pastel to create a luminous, matte finish. Art and music critic Paul Rosenfeld's interpretation of Dove in 1924 claimed that "[i]f he is generally found expressing himself through pastels, it is for the reason that the blue tones which he can achieve with them render to his satisfaction those very conditions of light recurrently established by his subject matters."[35] Rosenfeld was friendly with both Dove and Stieglitz and could have been told this by either of them. In only a few areas, as in the lower right of *Sails* (see plate 3) are underlayers of pastel allowed to show through to emphasize the depth of the surface and create a slightly rougher texture. This treatment is similar to the way remainders function in much modernist watercolor painting. Dove's surface finish is unlike the sketchier pastel application of many of the American artists who preceded him into the medium, such as Henri, Davies, and Marin. While Dove's composition seems drawn, with clean breaks between forms, he treats his pastels more like paint than like a graphic medium, placing his pastel style closer to that of

Redon than that of the illustrators of The Eight. This treatment may have been influential on the production of the pastels of Weber, O'Keeffe, and Stella, which share this smoother pastel finish.

The smooth, carefully controlled and modulated surface that Dove perfected in this first series of pastels seems to have set one goal for his oil painting style and technique in coming years. It is the smooth matte surface of pastel that Dove attempts to re-create and perhaps surpass in paint in the 1920s. Works like *Penetration*, 1924, and *After the Storm, Silver and Green (Vault Sky)*, c. 1923, have a controlled, soft surface much like that of the pastels and distinct from that of the more heavily painted irregular surfaces of the early oil abstractions, or even of his more thickly painted Post-Impressionist paintings done during his year and a half in France. The precedent of his work in pastel may even have encouraged Dove's experimental approach to the material of paint throughout his career.[36] Dove's use of metallic paint in the 1920s, long before the use of non-high-art paints became common, and his almost obsessive experiments with combinations of wax emulsion mediums, tempera, and oil paint in the 1930s and 1940s, may be seen as an ongoing search for a medium that would alter the refraction and texture of the paint surface so that it absorbed light like pastel, in contrast to the more glaring, reflective properties of oil. Watercolor, too, could have appealed to him as a medium in which the light travels through the paint and bounces off of the paper, rather than reflecting off the surface. His suns and moons of the 1930s, such as his watercolor *Sunrise*, 1937 (plate 14), testify to his concern with the radiance of light. Dove's care to see that these paintings appeared to glow from within may have begun in his early appreciation of the textural effects of pastel.

It is not only the surface texture of the pastels that is crucial to establishing Dove's "mature" style and artistic goals, however. Throughout the 1920s, Dove's paintings achieved their simple harmony and coherence through the use of rhythmic compositions often based on repeating curves and angles and through his use of limited, subtle color schemes. The artist first arrived at both of these stylistic signatures in the 1911–12 pastels. In a letter to the art dealer Samuel Kootz in the 1910s, Dove explained how this had come about:

Then one day I made a drawing of a hillside. The wind was blowing. I chose three forms from the planes on the sides of the trees, and three colors, and black and white. From these was made a rhythmic painting which expressed the spirit of the whole thing. . . .These colors were made into pastels carefully weighed out and graded with black and white into an instrument to be used in making that certain painting. . . . [37]

This description of the conception of *Nature Symbolized No. 2 (Wind on Hillside)* reveals how early in his artistic career Dove settled on the importance of color and basic form as the most salient aspects of nature and how early he arrived at the approach to abstracting these elements that would dominate his work.

Dove's penchant for compositions based on rhythmic repetitions, first seen in his use of patterned wallpapers as the backgrounds of his Fauvist still lifes, such as *The Lobster*, 1908, began to clarify in his small oil abstractions of 1909–10, specifically in *Abstraction No. 3* and *Abstraction No. 5*. It became the dominant compositional element, however, in the pastels. The repeating, gentle diagonals of *Sails* (see plate 3) create a series of yellow ocher triangles that tie the composition together in the same way that the repeating arches and ovals unify *Plant Forms* (plate 13), *Team of Horses* (see plate 2), and *Movement No. 1* (see plate 1). Although these pastels are composed entirely of interlocking, geometric shapes, which eliminate any sense of surrounding space in the images and draw the viewer into close, intimate contact with Dove's forms, the artist's paintings of the 1920s most often juxtaposed areas of repeating geometries with areas of open space, creating compositions more suggestive of traditional landscapes.

While the geometric repetition in *Sails* and *Movement No. 1* laid out the formal goals for paintings such as *Golden Storm* and *Chinese Music*, there is another stylistic variation apparent in Dove's later work that debuted in his pastels of 1911–12. Images like *Cow* (see plate 5) and *Calf*, two of *The Ten Commandments*, are composed not of regular geometric repetitions, but rather of interlocking skeins of organic, free-flowing lines, irregular curves that seem to respond to and echo each other, turning away when a collision threatens, but which don't relate in the same regular repetitions seen in *Sails*. While Dove did not continue with this kind of loose, organic drawing in the 1910s and early

1920s, it surfaced again upon his return to painting full-time in the late 1920s, in both his watercolors and larger paintings.[38] *Untitled*, n.d. (see plate 9), reveals Dove's later use of undulating, non-representational line to create a dynamic composition that seems to approach nature on the level of molecular structure or atmospheric movement. The freedom and expressiveness of line in *Cow* and *Calf* seem to anticipate the unfettered line of Surrealist automatic drawing. This may in part explain why Dove's series *The Ten Commandments* remained the most interesting of his works to immediately succeeding generations. Dove's return to a more traditional landscape format, complete with horizon and space beyond in his paintings of the 1920s, could be an additional factor in the continuing importance of the early work for younger artists. Ostensibly, these images were of the most interest because of their early break into abstraction. Dove's elimination in *The Ten Commandments* of the horizon and traditional landscape space to create a patterning that fills the entire surface may be an additional reason for their continued respect in the age of Abstract Expressionism.

Dove's letter to Kootz about *Nature Symbolized No. 2 (Wind on Hillside)*, 1911–12, pinpoints his discovery of his preference for a radically restricted palette. Dove's control over his palette thereafter was consistently premeditated and total. The colors of the early pastels range from the minimal palettes of *Movement No. 1* (see plate 1) and *Cow* (see plate 5), to the slightly more varied scheme of *Sails* (see plate 3), to the vibrant *Yachting*, c. 1912 (plate 16). Rarely did the pastels use more than three closely valued hues, perhaps with a vibrant blue added for contrast, as in *Sails*. Dove's color schemes received their share of attention in 1912 but were most deeply appreciated by Rosenfeld, who wrote of Dove that "[h]e has dark, pungent, gritty hues in his palette; dark subtle schemes and delicate gradations of earth-browns and dull shadowy greens and dirt-grays and intestiny whites that seem to flow from the body's fearless complete acceptance of itself."[39] Rosenfeld saw Dove's work as integrating the soul and the physical body in a Whitmanesque manner.[40] Like the pastels, Dove's paintings of the early 1920s, even while incorporating metallic paints, exploit the harmony and unity inherent in a radically restricted palette of closely valued hues. His paintings of these years never venture beyond four colors, often three similar in value and one stronger color for contrast and drama.

32

Rather than use prepared pastels and blend their colors on the linen or wood support, Dove prepared his own colors and blended them into carefully valued hues and shades for each work. As late as 1928, he continued to make his own pastels, "About four dozen carefully graded ones for each painting."[41] The texture and fragility of pastel required that colors not be blended into each other too heavily on the surface of the work, as the friction would destroy the light-absorbing quality of the powdery molecules and result in a muddy or glossy finish. This required that the artist have multiple shades of each color in the work available in pastel sticks because they could not be easily toned or combined.[42] The desire to control his unusually subtle, earthy color rather than be limited to what was commercially available may have been one factor in Dove's decision to make his own pastels. While commercial pastels were widely available in a vast range of colors and tints by the beginning of the twentieth century, some artists returned to making their own pastels after this expansion in the available color palette led to the use of fleeting chemical dyes in some colors. Because manufacturers failed to disclose a color's contents, some artists saw that the only way to ensure that their colors would not vanish with time was to mix their pastels themselves.[43] Dove was concerned with the durability of his work throughout his career. This concern was probably an additional factor in Dove's decision to mix his own pastel colors. The craftsmanship aspect of making his own pastels was also in keeping with Dove's personality. He made most of his own frames in order to be able to control their design and finish and occasionally made his own oil paints, boasting, "Grind own color now. Much better, purer than any but Blockx's. . . . I can make about $25 worth of cadmium for $1.60."[44] When Dove began experimenting with different paint mediums in the 1930s, the mixing and blending of the paint became its own artistic process, an essential precursor to beginning work on a piece. He was clearly predisposed to making his own materials throughout his career.

Dove continued to use pastels intermittently in the 1910s and 1920s, occasionally in combination with charcoal, as in his *Pagan Philosophy*. His charcoals and pastels of the 1910s reveal an interest in Cubism and in a complete, decentralized patterning of surface not seen in his large paintings until the late 1920s. Provocatively, pastels reappear in the first decade of Dove's work whenever he is undertaking a significant conceptual or stylistic shift. Surface texture and refraction of light were constant issues for Dove.

Perhaps the unwavering texture of pastel allowed him to concentrate on issues of composition and expression without the complications of questions of finish. His masterly control of pastel, and its lack of drying time, may additionally have allowed him to work on ideas of style quickly and without the complications of paint. His pastels of these decades are in no way subsidiary to the oils. In correspondence Dove always referred to his pastels, old and new, as "paintings" when discussing his work, as in his comment to Stieglitz that "[t]here are five large paintings. . . . One oil, three pastels and one in both mediums."[45] The pastels were full-size, finished works, which explored themes and stylistic variations similar to those in the oil paintings.

Pastel played a role in the stylistic origin of Dove's music paintings, an important subset of his work from 1913 to 1928. The idea that music could serve as a model of a non-representational, expressive art was popular among American and European artists at the beginning of the twentieth century.[46] Dove's paintings of his experience of music could have been prompted by Kandinsky's discussion of synesthesia in his *Towards the Spiritual in Art*, or by two watercolors by Francis Picabia, responses to a jazz concert, that were included in the 1913 exhibit at 291 where Dove and Picabia met.[47] Most probably, both of these artists contributed to Dove's decision to explore representations of music through the visual arts. His pastel, *Sentimental Music*, 1917 (see plate 4), was his second work with a musical reference. His first, *Music*, 1913, is a geometrically based oil painting that relies on the repetition of angles and curves in much the same manner as seen in *Sails* (see plate 3), *Plant Forms* (see plate 13), or later in *Golden Storm*. *Sentimental Music*, by contrast, is softly linear and flowing and sets the compositional pattern for several of Dove's 1927 music paintings. *George Gershwin—"Rhapsody in Blue," Part I*, 1927; *George Gershwin—"I'll Build a Stairway to Paradise,"* 1927; and even his more calligraphic *Improvisation*, 1927, all repeat the gently curving vertical lines placed just off center in *Sentimental Music* and echo the looping, curving forms swelling around the base and sides of this central element. While Dove returned to the more geometric, rhythmic patterning of *Music* in one other synesthetic work, *Chinese Music*, 1923, he seems to have discovered his preferred method of expressing the interaction of melody and harmony in *Sentimental Music*, as he retained that form ten years later when he embarked on his series of musically inspired paintings. This series would itself be an

important stage in Dove's transition from collage to painting at the end of the 1920s. As in his other pastels, Dove exploited the particular characteristics of the medium in his attempt to interpret music in pastel. The flicker of the pastels layered in short strokes of color gives *Sentimental Music* a soft, tactile surface, directed by the calligraphic black lines into ascents and rhythmic pauses along the support. The color scheme—carefully controlled dusty roses, muted teal, gray, and white—all controlled by the black lines echoes the "sentiment" of the title, creating the romantic mood of the piece.

While pastel's popularity as a medium declined after 1920, Dove continued to use it until about 1928, suggesting that he was less concerned with its trendiness than with its artistic qualities and potential. Indeed, in the late 1920s, at the same time that Dove was phasing out his use of collage and beginning to work in watercolor he executed more works in pastel than he had since he had first developed his artistic vocabulary in *The Ten Commandments*. It is possible that, as in 1911–12, Dove chose in 1927–28 to explore his ideas of pictorial representation in the more controllable, draftsmanlike medium of pastel. Unfortunately, many of these pastels are currently unlocated, making it impossible to determine if, as a group, they contain the formal beginnings of his work of the 1930s. Those that do remain, however, are closer to his organic style of the 1930s than to either his paintings and pastels prior to 1925 or his paintings of 1927–28. Works like *Tree Forms*, 1928 (plate 15), may well have allowed Dove to work out aspects of his evolving approach to extracting the essence of the landscape in a familiar medium.

The rich patterning of the dark, almost brooding image in *Tree Forms* suggests the kind of abstraction that Dove would use most expressively in the 1930s: an intricate surface clearly derived from the landscape or its elements, often pushed just to the edge of non-objectivity. While the composition of *Tree Forms* belongs at the beginning of Dove's work of the next decade, its materials, pastel on wood, are comfortably part of Dove's past. Pastel and wood, usually separately, had been components of his artistic practice for years. While he had done two earlier pastels on wood supports, in these works Dove had not been interested in the unique potential of this rather unusual combination. In *Tree Forms*, by contrast, Dove alternately exploited the texture of the grain of the wood board and camouflaged it by allowing the rust-tinted pastel used in the lower half of the composition, especially on the left, to appear to settle into the grain,

while smoothing the blacks and grays of the upper half of the work into the velvety texture seen in his earlier pastels.

Dove's proficiency with pastel may have enabled him to use it in this work to explore some of the most progressive ideas in European art. Ann Lee Morgan has suggested that *Tree Forms* may be an experiment in frottage, Max Ernst's Surrealist method of deriving an image from the marks left by rubbing charcoal, pencil, crayon, or paint on paper placed over a textured surface,[48] a technique Dove would have been aware of from his reading or gallery visits. An interest in aspects of Surrealism clearly appears in the convoluted line, reminiscent of that produced by automatic drawing in numerous of Dove's watercolors and paintings of the 1930s, supporting the idea that he would have been inclined to experiment with other aspects of Surrealism. This work also retains some of the wit of his collages and the layering of levels of representation of classic Cubist collage. Dove allows the wood of the support to show through the layered pastel, so that the actual physical wood provides the textural flicker, the graining, for Dove's pastel representation of a wood log. Dove would certainly have been aware of the irony of representing wood on a wood support and allowing the two to interact.

Watercolors

While each of Dove's pastels was meticulously planned, Dove's watercolors were executed spontaneously and swiftly, capturing single moments in time. Like the impact of the pastels on Dove's work of the 1920s, however, the particular formal characteristics of watercolor came to effect Dove's larger paintings of the 1930s and 1940s. The expressive style of his organic abstractions and luminous celestial images of the 1930s and the unmodulated color of his more geometric paintings of the 1940s both reveal traces of the unique effects of his watercolor technique.

While there are at most two dozen surviving Dove pastels, his watercolors easily number in the hundreds. In their proliferation they give us the most complete picture of Dove's world and how he sought to represent it. In images that range from caricatures to the completely abstract, Dove shows us the full range of his life in the landscape of the

American Northeast: lakes, harbors, mountains, willow trees, cows, cats, seagulls, swans, street scenes, boats, a waterslide, construction equipment, factories, barns, sunrise, sunset, his wife, her sewing machine (see, for example, plates 17–19). All are distilled on paper with a few strokes of black ink and watercolor. Dove's watercolors are also significant in the history of American watercolor painting. While begun late in the resurgence of watercolor painting in the United States, and crude in technique if compared to Demuth's or Hopper's watercolors, Dove's demonstrate how the simplest approach to the medium could result in elegant, vivacious images. Strongly gestural, with an uncomplicated directness and a vigorous, flat application of paint, Dove's watercolors may even be seen as prefiguring Abstract Expressionism.

Dove's return to painting in 1927 appears to have been immediately followed by his initial experiments in watercolor, the earliest extant examples of which date from 1928. These small works served as preliminary compositions for larger paintings, as a visual diary for the artist, and as a means of artistic experimentation.[49] Dove seems to have turned to sketching in watercolor as part of his shift toward a more traditional approach to the creation of the final, large painting in the late 1920s following his experiments with collage.[50] With the end of his part-time work as an illustrator around 1930, Dove was able to devote himself to painting more fully than ever before. The watercolor sketch was an important part of his painting process. By 1930 Dove was executing enough watercolors to include a group of them in his annual show at Stieglitz's gallery. Thereafter, Dove created hundreds of watercolors, "ideas for paintings," each year, working almost exclusively on the watercolors in the late spring through the early fall. It was not unusual for him to have over a hundred watercolors mounted by midautumn.[51] The artist added wax emulsion mediums and tempera paint to his tools for sketching in the mid-1930s.

As Dove's primary artistic expression for half of each year, and the initial conception of each of his larger works, the watercolors and sketches have to be seen as an important component of his artistic output and artistic development in the last two decades of his career. While they were unquestionably executed as potential studies, Dove clearly recognized their independent value as works of art by 1930 when he began including them in his annual exhibitions. He also sold them, gave them as gifts to family and friends, and occasionally gave them in repayment of small debts. He must have felt that

they were an acceptable public representation of his work. The critics and his few early collectors also acknowledged the appeal of his watercolors, and their sale supplemented his often meager income. The reputation of watercolor as an important component of a distinctly American modern art further suggested that Dove at least contemplated considering his watercolors as independent works of art, rather than as subordinate to his oils. The critics who commented on his watercolors after he began exhibiting them in 1930 often chose to view them this way and evaluated them independently of their relationship to his larger paintings.

The watercolors, and later the so-called sketches, were crucial to Dove's working method in the 1930s and 1940s. The initial conception of the work, the first manifestation of the idea or the image, was recorded in watercolor. Dove was aware that his watercolors served this function. In late May 1936 he wrote to Stieglitz, "The work is going fine—about 12 watercolors. Reds joins me in thinking that they are starting off bigger than the end of last season's. Anyway there is a bit of new idea added which is always a stimulus."[52] By 1932, virtually all of his major paintings originated as one of these smaller works, often executed months before Dove began painting on canvas. "I often find it difficult to do an oil from a watercolor that hasn't been done with the oil in mind,"[53] he wrote in 1934. That the oils generally show only minor changes, adjustments even, from the color and composition of the watercolor, reveals the extent to which the watercolors captured the essence of what Dove wanted to express in the final painting and the speed with which he was able to compose a painting. Further, the works on paper provide a more complex picture of how Dove's style developed in the 1930s and 1940s than do his large paintings alone. The combination of the watercolors that served as studies for paintings and the hundreds of compositions that Dove chose not to enlarge into full-size works, demonstrates how the artist worked through the formal and theoretical developments of European and American modernism in the 1930s and 1940s before integrating them into his own work. Unlike his colleagues at An American Place, O'Keeffe and Marin, whose styles changed little after the 1920s, Dove persistently pushed his work. His diaries and letters are optimistically full of the declaration that the current painting is the "best yet." The watercolors and sketches were an important tool for Dove in reaching that "best yet," allowing him to work out stylistic questions and imparting their own formal characteristics on his larger works.

Finally, the watercolors allowed Dove to work with subjects he probably knew he would never do as full-size paintings. In the mid-1930s Dove painted several watercolors of the human figure. *Woman Sleeping, Italian Child*, and *Portrait* are among them. His most common human subject, unsurprisingly, was Torr, whom he sketched periodically. Perhaps he considered adding a figural element to his work in the mid-1930s. It is more likely, though, that these were never considered for enlargement, as the human figure was almost entirely absent from Dove's large paintings, and these watercolors were rarely included in Dove's annual exhibitions.

Suzanne Mullett carefully recorded the watercolors and their exhibition history in the card catalog of Dove's work that she initially compiled in 1943, adding to it until the mid-1970s. She was supplied with forms suggesting what information to include by the American Federation of Arts, which asked only that she catalog major works. She worked closely with Phillips, Stieglitz, and Dove on this project. Any of the three could have suggested that she also include the watercolors. Her willingness to undertake the vast project of cataloging Dove's hundreds of watercolors suggests the esteem in which these works were held by those closest to the artist and by Dove himself. While the card file records dozens of watercolors, it seems to be only a partial catalog. As the card file was first assembled in 1943 from works in storage, at An American Place, and from Dove's and Stieglitz's memories, it is entirely plausible that some works, particularly those that were sold or given away early, were not included. Dove's "sketches"—his smallest works in watercolor, tempera, oil, or wax emulsion—were predominantly omitted. This must have been a deliberate omission, for these works remained in Dove's possession and would have been available for cataloging.

Dove may have included a watercolor in his annual exhibition as early as 1929. The Intimate Gallery catalog for his show of that year lists no. 18 *Kingfisher, Port Jefferson*, 1927, a title to which no located oil corresponds. Suzanne Mullett's 1943 card file places this work in 1927, noting that it is stored in the Lincoln warehouse and is 8 1/2 x 11 inches, "oil, ink and wc on paper." She also noted that it was signed on the back in crayon in 1929 and shown as no. 18 in the 1929 exhibition.[54] Dove occasionally mixed oil and pastel at the end of the 1920s. Perhaps his first experiments with watercolor were attempts to find other mediums, other textures, with which to vary the surface of his oils.

This would have been in keeping with his flexible approach to the medium of paint. From the early 1920s when he incorporated metallic paint into his oils through the 1930s and 1940s when he often combined oil, tempera, and wax emulsions on the same canvas, Dove had no aversion to mixing his mediums. Apparently these first experiments with combining watercolor and oil were not entirely satisfactory; Dove rarely used this combination in large works in the following years, although he did so occasionally in his small sketches. His watercolors after this point are primarily mixtures only of pencil, ink, and watercolor until the mid-1930s when he sometimes combined watercolor with tempera or wax emulsion.

In 1931 and 1932, still on Long Island, Dove apparently worked on watercolors and oils simultaneously in the spring and summer, unlike his later pattern in Geneva. This was productive time for Dove, and he noted to Stieglitz that he was doing "a watercolor a day at least. And the oils are beginning to keep pace."[55] He also mounted and framed watercolors in batches as they were done, with "about 25 watercolors quite beautifully framed in matte silver"[56] by early August 1932. The increasing pace at which he produced watercolors was already evident. He noted to Stieglitz in July 1931 that the watercolors were "ahead of last year's similar preliminary and as to time, two months earlier."[57] Dove and Torr's diaries reveal that their July 1933 move to Geneva dominated that summer, and Dove was able to do little painting of any kind from early June through September of that year. When he began painting again in October his first works were in watercolor, and he worked on both watercolors and larger paintings until early January, when his focus shifted to completing the large paintings for his spring show. He resumed painting in watercolor immediately after packing the paintings for his show in April 1934, beginning a more segregated and consistent schedule of watercolor painting. From 1934 until the mid 1940s Dove did watercolors or sketches, as he sometimes called them in his diaries, predominantly from April through September[58] (see, for example, plate 20).

Dove used his works on paper much as a visual diary, carrying a pad of watercolor paper with him in Geneva and Centerport. A May 1935 diary entry mentions that "Arthur arranged painting bag."[59] Watercolor's portability was well suited to Dove's desire to be out in nature; he made watercolors in the woods, in his boat, in his car, and on the train. This allowed the artist to record his immediate responses to nature and to note

his ideas for paintings quickly, and it also encouraged a concise depiction. "Arthur did water color out in yard"[60] and "Arthur did water color of willows on Lake road"[61] are typical entries in the diaries kept by Dove and his wife in the 1930s and 1940s. The diaries report that he often completed several sketches in a day, although they only occasionally reveal the subjects of those works. He also occasionally did series of studies of a single subject, searching for the purest form of expression before committing the composition to canvas. On those days in the 1940s when illness prevented him from standing at an easel, the lightness of a pad of paper allowed him to continue working on watercolors or oil and wax emulsion sketches.

When the weather cooled, Dove spent a few days mounting great numbers of watercolors and then selected compositions from the summer's production to enlarge into the year's oil or oil and wax emulsion paintings. While Dove continued to do a few watercolors in the fall and winter, these months were generally devoted to painting in heavier mediums and mounting and framing oils and watercolors for his early spring annual exhibitions.[62] The less than luxurious conditions in which the Doves lived, even in Geneva, may not have encouraged watercolor painting into the winter: ". . . 8° above 0 this A.M. Ink and watercolors froze while working. Had to keep breathing on pen & brush. . . ."[63]

Dove used a pantograph and, in the 1940s, a "magic lantern" to transfer the compositions from paper to canvas. The pantograph, which in Geneva he used at the Agricultural Experiment Station, worked by transferring the image to canvas with one arm while Dove traced his watercolor with the other. The "magic lantern" may have been a slide projector or an opaque projector.[64] Dove's use of these devices suggests that he recognized the immediacy and spontaneity of these works and sought to preserve this quality in his larger paintings by transferring the composition as directly and precisely as possible. As he wrote to Stieglitz in 1931, "To express an emotion in the colored drawings is one thing, but to take that and make every part of it do all that, keep its feeling, and exist in its own space is another."[65] The larger paintings apparently had to meet a stricter set of standards to be judged acceptable to the artist. Where the notation of an emotion or idea was ideal for the quickly executed watercolor, he wanted his larger paintings to be more unified in their expression, so that each part of the composition

and color contributed to the overall impact. Part of the process of selecting which watercolors to enlarge may have been an estimation of which had the potential to be the most cohesively expressive in a larger format.

As thorough as Dove and Torr were in recording the initial creation, mounting, and framing of the watercolors in their diaries, it was predominantly physical acts that they chose to record. While they occasionally noted that they "looked over sketches,"[66] their diary entries never explain the criteria Dove used in selecting which watercolor compositions to enlarge. Torr seems to have participated in reviewing the watercolors, and in at least one recorded instance, Dove did a painting that was referred to in the diaries only as "the one that O'Keeffe liked the watercolor of."[67] Torr sometimes designated the watercolors "swell," or "lovely," or even "fine," but this was relatively rare, and without precise dates on the works or precise discussions of subject matter in the diaries, it is difficult to determine whether or not these works became the bases for larger paintings.

In 1935, Dove acquired a copy of Max Doerner's *Materials of the Artist* and increased his experimentation with different compositions of wax emulsion and tempera paints.[68] He tested the handling, finish, and durability of these paint mixtures in small sketches on paper. *Untitled #12*, c. 1941, in its size and opaque medium is similar to the small sketches. While these sketches were only occasionally used as preliminary studies for larger paintings in Geneva, they became a more frequent source of composition after Dove and Torr moved to Centerport, Long Island, in 1938.[69] However, Dove continued to take his watercolor supplies when he could venture out on Long Island, apparently still finding them more portable. He and Torr often visited the nearby harbor town of Northport when they first arrived in Centerport and "made watercolors." On Long Island, the wax emulsion and tempera sketches took on a regular 3 x 4 inch size, which the artist's son has explained as being the size that fit the "magic lantern" that Dove was using to enlarge compositions in Centerport. Dove's restriction of these works to the size that fit the "magic lantern" suggests that he intended these works primarily as studies for possible paintings, or at least wanted to retain that option.[70]

Stieglitz had long been a supporter of a democratic approach to the various artistic media. While he continued to view Dove's larger paintings as his major works, he respected the watercolors and sold many of them through The Intimate Gallery and An

American Place. Certainly he encouraged Dove's venture onto paper. After visiting his 1932 show at Stieglitz's gallery, Dove wrote to the photographer that "[s]ince your saying the other day that you wished you had a hundred more of the sketches, I have looked through a large box containing all the drawings that had been put aside to make paintings of, and some that have been painted from the last two years. Have picked out twenty of them and mounted them."[71] The price difference between the paintings and watercolors remained enormous, however. While Dove's paintings sold for several hundred dollars, still low compared with the prices of O'Keeffe's or Marin's works, his watercolors often sold for under fifty dollars each, sometimes for as low as twelve or fifteen dollars in special cases. In pricing at least, Dove and Stieglitz respected the traditional hierarchy between sketch and painting.

Dove had begun including watercolors in his annual exhibitions at Stieglitz's An American Place gallery by 1930. In 1931 Edward Alden Jewell in his review of the Dove annual for *The New York Times* pointed out that "[i]n one room will be found small water-color sketches made in preparation for the larger works in oil,"[72] without further comment on their quality. In 1932 Dove exhibited an equal number of "Framed Sketches" and "Paintings," including the watercolors for more than half of the paintings.[73] Dove had clearly begun to derive his major paintings from preliminary watercolors. Among the "Paintings" and "Framed Sketches" with corresponding titles noted in a handwritten exhibition checklist were *Pine Tree, Red Barge, Steam Shovel, Breezy Day, Fields from Train, Broome County*, and *Car*.

While the watercolors were listed in published Stieglitz catalogs merely as a single lot, "watercolors," after a listing of titled paintings, Dove always carefully mounted and framed the watercolors, using purchased frames that he "silvered" to match the handmade finish he gave the frames for his larger oils. Some of the watercolors were apparently assigned titles before they were enlarged into paintings, as Dove and Torr were generally able to relay his progress on a painting in their diaries using its final title. The last thing that Dove and Reds did before shipping the watercolors off to Stieglitz was title those that hadn't been enlarged and label them all. Dove also sent unframed watercolors to his exhibitions, to be shown in portfolios. At least once Stieglitz sold a watercolor off the wall during the exhibition and replaced it with one from the

portfolios. Not listing the watercolors individually in the exhibition brochure may have been in part a pragmatic move designed to allow the impulse buyer to leave the gallery with a Dove without corrupting the catalog. Dove's inclusion of the watercolors in his shows, even of those that he hadn't chosen to enlarge, and his early habit of signing them, reinforces the idea that he recognized their value as independant works of art and felt that they were representative of his work. Among those who bought Dove's watercolors during his lifetime were Phillips, Stieglitz, O'Keeffe, the architect Philip Goodwin, Charles Brooks, the critic Elizabeth McCausland, a professor at Hobart College, virtually every doctor that Dove or Torr saw in the late 1930s and 1940s, and occasionally, people "off the street." Letters from Stieglitz that included an unexpected windfall, such as "I am enclosing check for $40.00. A working girl bought one of your watercolors,"[74] were cause for celebration. The importance of Dove's watercolors in his work was recognized quickly by those who appreciated his paintings. As early as 1933 Elizabeth McCausland organized an exhibition at the Springfield Museum of Art composed entirely of fifteen Dove watercolors. While no catalog from this exhibition remains, Suzanne Mullett's 1943 card file of Dove's work noted each piece's exhibition history, allowing for a tentative partial reconstruction of the exhibition.[75] Duncan Phillips featured thirty-five watercolors in his 1937 Dove retrospective, which included only fifteen oils, four collages, and two pastels. In his essay for the exhibition catalog Phillips remarked on the delicacy of the watercolors, writing, "Dove's little drawings with their calligraphic lines and washes of subtle color, are abbreviated notes from nature."[76]

Watercolors: Technique and Style

I do not attempt to grind water color as they have to be ground so fine and mixed so carefully for each separate color. The manufacturer can do it better than the artist. . . . I use fountain pens made especially for Higgins water proof ink for the drawings and watercolors, or just a pencil with the colors written in for some of the sketches, or sometimes a Woolf 3B crayon pencil. Sometimes God helps with a fine misty rain as in one you saw done from the lake. —ARTHUR DOVE [77]

Unlike his exacting approach to the pastel medium and the material composition of his paints, Dove was perhaps most willing to surrender some control over his artistic output in the watercolors, allowing himself to use commercially prepared paints and accept and even embrace the occasional contribution of an accidental drip or misty drops of rain. Dove's watercolor technique was uncomplicated and direct, enhancing the relaxed spontaneity of his attitude toward his sketches. Watercolor as a medium required a lighter, faster touch than did his more solid, deliberate paintings. Dove was responsive to the particular qualities of the medium and developed a sensitivity to its possibilities that allowed him to take advantage of its unique effects. He exploited watercolor's fluidity and speed, its ability to bleed into the paper or other colors, and even attempted to capture some of those effects in some of his larger paintings. Watercolor was not a portable substitute for oil in Dove's mind, but a medium with its own expressive potential that at its best could reshape his work in heavier paint.

Dove's watercolors are remarkably diverse in style, and particularly appear so when viewed next to the more consistent and subtly shifting style of his larger paintings. Indeed, the watercolors and sketches contain the more extreme stylistic explorations, which Dove then brought closer to his existing body of work, both through his selection of images to enlarge and in their handling in oil or other heavy paints. Dove's oil paintings range from fairly representational images such as *Car*, 1931, to the non-objective paintings of the early 1940s that deny a source in the landscape or in landscape space. His watercolors take each of these modes further, ranging from representational sketches that are almost cartoonlike in their quick summaries of the world, to experiments in Surrealism whose degree of abstraction in the 1930s goes beyond that found in his contemporary paintings.

Regardless of whether a sketch was illustrational or non-objective, however, Dove's watercolors share the rapid definition of each form with a single sweep of clear color. Dove most often used his watercolor dry enough to allow remainders of the paper to show through and the line to be tightly controlled. He also, though less often, used more watery paint, which encouraged colors to bleed into each other and spread softly across the paper as in *Brown Sun and Housetop*, 1937 (plate 21). Both of these styles had precedents in the modernist watercolors of preceding years. John Marin most often used

the dryer brush effect in his dynamic, glittering watercolors, whereas Georgia O'Keeffe specialized in the languid sweep of wet color. O'Keeffe had indeed used her watercolor much as Dove did, often defining forms with a single sweep of color largely distinct from those around it, as in her *Blue No. 1*, 1916 (figure 4).

Dove's watercolors differed sharply from those of the other American modernists, however, in their exploitation of line to define and enliven the composition. Dove's use of line was closest to that of Marin, but he rarely used line as a compositional element independent of color as Marin did. Most of Dove's watercolors appear to have begun as drawings, usually done with a fountain pen, but sometimes with charcoal or pencil. Here we see the quality that made the artist a successful illustrator during his first years in New York: the facility with which he could capture the essential characteristics of a scene with no more than a few sweeping, jumping lines.

The freedom of Dove's line, perhaps first seen in his 1911 *Cow* (see plate 5), which he called "an example of the line motive freed still further,"[78] made it one of the strongest compositional elements in his paintings of the 1930s.[79] Dove's experimentation with line as a compositional element had continued as a secondary interest throughout the 1910s and 1920s, as in *Sentimental Music* (see plate 4), resurfacing as a major concern in the music paintings of 1927.[80] In works like *Abstraction, Autumn Leaves*, 1938 (plate 22), *Untitled*, n.d. (see plate 9), and *Canandaigua Outlet, Oaks Corner*, 1937 (plate 23), the line that had arabesqued across the picture plane independent of form in *George Gershwin— "Rhapsody in Blue," Part I*, 1927, defines form and controls the composition as a whole. The weightiness and solidity that infused more geometrically linear works of the 1920s like *Penetration*, 1924, and *Thunderstorm*, 1921, had dissolved by the early 1930s into a more lively surface patterning that defies both depth and weight. Even buildings can wriggle mirthfully as in *Brickyard Shed*, 1934, and the watercolor of *Exchange Street, Geneva*, 1938 (plate 24), controlled by lines that move the eye continuously around the canvas. Dove first began developing his watercolor technique, so dependent on the initial, vigorously drawn line, in the year after his series of music paintings. It may be that these jazz paintings alerted Dove to the ability of free-flowing line to activate the painted surface. Alternately, the amorphousness of watercolor may itself have suggested the necessity of an enclosing line. Dove's illustrating experience put him firmly in

Figure 4. Georgia O'Keeffe.
Blue No. 1. 1916. Watercolor
on tissue paper, 16 x 11 in.
The Brooklyn Museum of Art,
New York

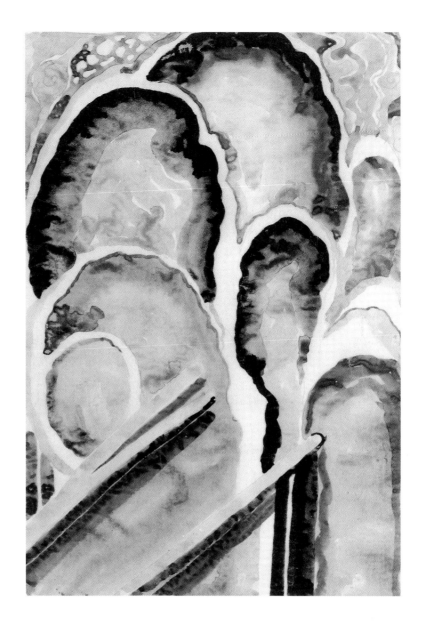

control of the poignant line. Regardless of the ultimate source of the linearity that
dominated Dove's watercolors, the ease with which Dove inscribed his compositions in
ink and watercolor was translated into the vigorous line of so many of his paintings of
the 1930s.

While Dove may have experimented with watercolor as early as 1910, or possibly
even at Cornell, his earliest located watercolors from the years of his reliance upon the
medium as an integral part of his working process, such as *Distraction* (see plate 6), date

from 1928. *Distraction* is much larger than the vast majority of Dove's watercolors would be in the 1930s, closer to 9 x 12 inches than to the 4 x 6 inches that would be the usual size of his watercolors in the 1930s. His watercolors for *Sandbarge*, 1930, and *Across the Harbor*, 1930, are also among the works in this larger format. Dove may have begun working in this size because he felt at the time that it was more practical for studies to keep fairly close to the size of the final work or because he intended to exhibit and sell the watercolors and thought that larger works would command more attention. Most likely, however, this was simply closer to the size he was accustomed to using. Dove may not have appreciated the portability of the smaller pad of watercolor paper until several years after he began working in the medium. The switch to smaller, 4 x 6 inch or 5 x 7 inch paper seems to have occurred in 1931 or 1932.[81]

Distraction is an almost calligraphic, minimalist image: a few lines of brown and black ink, sometimes watered down to gray, punctuated with a hit of fuchsia and a broad sweep of yellow. Dove's use of watercolor here is clearly exploratory. The yellow is slashed on confidently and bleeds into the paper, while the fuchsia is dry and drawn on in a linear scribble. The untouched paper is as important to the balance of the image as what the artist has added to it. The subject matter is ambiguous, and the title of little help, in contrast to Dove's usual, concrete, physical titles. There is an unmistakable horizon, however, and in the context of Dove's work the image unavoidably suggests his pulsating suns and moons of the 1930s. While the title will not confirm any theories, *Distraction* may well be the first sign of Dove's fascination in the next decade with celestial objects.

Another frequent subject of the early 1930s that Dove investigated thoroughly in his watercolors was the machinery of the harbors and roads of northern Long Island. The watercolor *Sand Pits, Port Washington*, 1931, and the oil painting *Derrick*, 1933, are comparatively representational images of construction equipment in the landscape. *Sandbarge*, 1930, and *Forms*, 1932, present more abstracted interpretations of similar subjects. The geometric arcs and trapezoids in *Forms* suggest, rather than depict, the derricks, cranes, and scaffolding of modern machinery. The details are telling: The diagonal slice of clearly recognizable metal scaffolding at the left makes explicit the mechanical nature of the subject. It simultaneously suggests a connection to Fernand

Léger's Synthetic Cubism of the 1920s, in which his abstractions of the city were punctuated with clearly drawn fragments of ornamental or utilitarian ironwork. The reductive, linear geometry of the image, and its total lack of spatial recession, are unusual for Dove's more organic imagery of the period. This work may have been a deliberate experiment with a more classically Cubist idiom, perhaps prompted by the "modern" character of the subject, as opposed to the more timeless landscape that was his more frequent concern. This composition was apparently too reductively geometric for Dove to chose to enlarge in the early 1930s. The derrick that he did as a full-size painting was more representational and set into a natural landscape. Dove did send *Forms* to his annual exhibition at An American Place in 1932, however, unframed, to be included in the portfolio of watercolors available for viewing.[82] The flat, hard-edged geometry of *Forms*, was not reserved for mechanical subjects, however. Dove's 1930 landscape *Swinging in the Park* (see plate 8) borrows from Cubism and Futurism to use a grid of lines, both straight diagonals and curves, to depict sweeping motion through a landscape. The grid makes the watercolor at first glance seem completely flat, without any space for swinging, until the eye traces one of the curves that bends from the top to bottom of the image. Then the image seems to bend out with the line, creating a space around the central tree trunk. While the pale yellow, peach, and gray color scheme is suggestive of the colors of high Analytic Cubism and adds to the flatness of the work, the scalloped, pale green foliage and the brown tree trunk, which itself seems to swing, allow the eye to perceive space and identify the work as a landscape. While this watercolor is signed on the back, it appears to have been signed on the front in pencil in another hand after its 1931 exhibition at An American Place. This signature is in Dove's customary spot, the bottom center, here identified as the middle of the green foliage. As Suzanne Mullet's sketch of the work in her catalog of Dove's paintings shows this foliage at the top,[83] the work appears to have been signed upside down, the signer mistaking the green foliage for grass or bushes at the bottom, when it is actually leaves of the tree and should be at the top (figure 5). Orienting the foliage at the top also reveals an abstracted figure to the left of the tree trunk, a person "swinging in the park."

Dove's skill as an illustrator and his ability to capture the essence of a subject with a few swift, detailed lines found perfect expression in his more representational

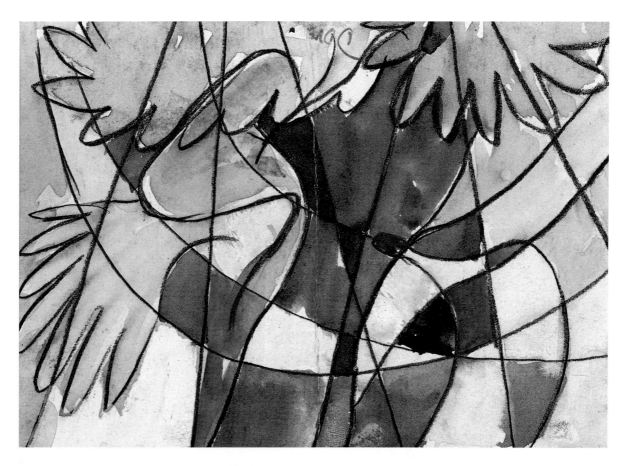

Figure 5. Arthur Dove. *Swinging in the Park*. 1930. Watercolor, 4 5/8 x 6 3/4 in.
Colby College Museum of Art, Waterville, Maine

watercolors, such as *Beach Umbrellas*, 1931 (plate 25); *Boat*, 1932 (plate 27); and *Exchange Street, Geneva*, 1938 (see plate 24). These works, occasionally humorous, even cartoonish in their representation of the things and animals that composed Dove's world—boats, cars, cows, and barns—reveal a deep appreciation of what others might consider the mundane or banal aspects of everyday life. His ability to mine the world around him for inspiration, creating abstract beauty from his rapid, incisive grasp of the construction of a street scene or field of cows, is demonstrated most directly in the range of representation in these watercolors. *Exchange Street, Geneva* generalizes just enough to caricature: Dove's beetlelike cars, their wheels peering at

the viewer like big, round eyes, travel down a road hemmed in by trees and buildings to which the artist has given a castellated top, like a medieval fortress. It is an image that was obviously intended to be amusing. Dove thought enough of it to include it, unframed, in his 1938 exhibit at An American Place.[84] His *Boat* is a more appreciative study. In this watercolor Dove carefully delineated the details of the bow of a seemingly grand sailboat. This is not an image that seeks to get at the essence of the form; even the chains are picked out, link by link, in contrast to Dove's usual, more generalizing approach. Of course, in 1932, boats still played a significant role in Dove's life. Is this the boat on which Dove and Torr lived or another he encountered in his travels? The diagonal, cropped composition suggests its progress through the water and recalls the cropping of photography. While the style of *Boat* is not exceptional, it is a lovely example of the richly subtle color palettes of Dove's watercolors. Painted on tan paper, as is *Beach Umbrellas*, *Boat* combines three shades of brown: deep umber, reddish sienna, and pale, yellowy beige, and a bit of black. Toned down by the tan paper, the color scheme might be lifeless were it not for the blue-green he uses selectively to contrast the red tones of the sienna and the yellow of the beige. Combined with the sienna, the green creates the perfect suggestion of the dark water of the harbor or the Long Island Sound. *Boat* appears to contain numerous different colors, all of which Dove created by varying the amount water in probably no more than three or at most four colors of watercolor paint. While Dove enlarged these illustrational watercolors into finished paintings less often than other kinds of images, they were not done casually. When the artist did use these representational watercolors as the source of an oil it was with modifications that brought the images more in line with his established, abstracting style. Dove would certainly have been aware that these watercolors were not consistent with the usual degree of abstraction in his work, and he must therefore have had another motive for their execution. While Dove made these more illustrational sketches throughout the 1930s and 1940s they seem to be most abundant in the early 1930s and again around 1938 to 1940, perhaps suggesting that they served as a tool through which Dove acquainted himself with his new surroundings, working at understanding them first more or less "realistically" before moving on to a more essentializing approach. In at least one instance, Dove

processed an image through a series of watercolors until an acceptable degree of abstraction was reached.[85]

While Dove's illustrational watercolors are in many ways less avant-garde than the majority of his paintings, the artist also used his watercolor and wax emulsion sketches to explore the most avant-garde tendencies in American and European modernism. As we have seen, Dove's work had distanced itself from the representational before, particularly in his paintings that sought to function as equivalents for music or as depictions of his response to music, like his pastel *Sentimental Music* (see plate 4). In his watercolors, however, Dove worked repeatedly at the boundary between representation and abstraction.

Dove painted cows whenever he had the opportunity; they were a common subject in Westport and again in Geneva. Dove's early pastels of the animals, like *Cow*, c. 1911 (see plate 5), are abstract representations that seek the essence of the natural world. In Geneva, however, Dove subjected what was apparently his favorite farm animal to the full range of his skills, from caricature to complete abstraction. The watercolor *From Cows*, 1937 (plate 26), is somewhere in the middle, evoking a small cluster of probably three bovines, perhaps one grouping a mother and calf, with blocks of color. The pattern of browns and blacks would be a serious suggestion of animals in connection with their natural environment if it weren't for the humor of the white spots Dove flickered on top of the brown cow at the bottom center. Despite this light note, however, the abstraction of the image indicates that it was done as a potential study for a larger painting. Dove's interest in the blocks of color that suggest a cow, rather than in the lines that suggest a cow as in his past images, may position this work between his more linearly organic images of the mid-1930s and his geometric images of the late 1930s and 1940s.

One of Dove's first oils after he resumed painting in 1927 was *Seagull Motif, Violet and Green*, 1927, an image dominated by a giant lavender triangle surrounded by the looping arabesques of a series of black lines. It is an image as much drawn as painted, and it foreshadows Dove's exploitation of line in his watercolors as a compositional element free from the restraints of faithful representation of nature. Just as Dove could use line like a caricaturist or an illustrator, he could also use line to create non-objective compositions whose apparent freedom and spontaneity suggest that he was deliberately exploring the

use of some aspects of the European Surrealists' automatic drawing. Dove was familiar with the work of Masson and Miró and was particularly interested in Paul Klee, whose use of heavy outlines in his own watercolors, such as *Land of the Lemons*, 1929, may have additionally influenced Dove's approach. Watercolors like *Abstraction, Autumn Leaves* (see plate 22) and *Untitled* n.d. (see plate 9), exploit the meanderings and intricacies of each line to form complex images that border on non-objective with a minimum of means; *Untitled* is composed primarily of only three lines, aligning it with the automatic drawings of Masson. However, these compositions remain evenly balanced and harmonious, like Dove's earlier pastels, and generally lack the arbitrariness that might be expected in truly automatic drawing.

Dove could also use the line that arabesqued into so many complex, highly patterned compositions with an almost Zen-like simplicity. *Flour Mill II*, 1938 (plate 29), exhibited at An American Place in 1938[86] and *A Barn Here and a Tree There*, 1940 (plate 28), reveal the restraint with which Dove could effortlessly cut to the essence of his subject, using two colors and a few uncomplicated lines. The vertical sweeps of gray and yellow in *Flour Mill II* could have defined anything or nothing; only the single scalloped line at their tops signals the roundness and solidity of silos. The image has lost all the humor of *Exchange Street, Geneva* (see plate 24), embued rather with a monumentality not unlike that of O'Keeffe's paintings. Dove chose not to enlarge this version of the flour mill, but instead selected one in a much less illustrational, abstract style.

While the vast majority of Dove's watercolors in the 1930s and 1940s began with his skipping line, a small but significant portion of them eliminated that drawn line, relying instead on unrestrained color to create a softness not seen in his more linear works. This technique worked best for Dove in his studies of the sun. *Sunrise*, 1937 (see plate 14), and *Brown Sun and Housetop*, 1937 (see plate 21), achieve their glowing radiance from the delicacy of Dove's washes of blues, grays, and purples. The layering of washes of color in *Sunrise*, relatively rare in Dove's watercolors, gives it a depth that emphasizes the embracing quality of the sun's light, while the remainders, the revealed flecks of paper, add sparkle and suggest the blinding glare of looking into the sun. The single line of black ink, partially setting off the pale yellow sun, is crucial in anchoring the image and adding just enough asymmetry to make the essentially symmetrical

image dynamic. The splashes of water in the lower left, perhaps a happy accident, further enliven the image and suggest the "sunspots" that Dove often included in his paintings of the sky. *Sunrise* appears to be the preliminary study for *Sunrise III*, 1936. The colors are darkened considerably in the larger wax emulsion and oil painting but are generally in the same family. The placing of the yellow sun just off center is the same, and the single black line that defined that sun, now navy and more delicate, is clearly from this watercolor.[87] The overlapping shades of purple and blue at the lower right of the oil, breaking out of the regular concentric pattern, reveal that in the larger painting Dove attemped in some areas to duplicate the effect of the layered, translucent, colored washes that gave the watercolor its depth. Even the fine, orangy specks of light that encircle the center of the sun are repeated delicately in the large painting.[88]

In *Brown Sun and Housetop*, Dove uses his watercolor even more freely to suggest a constantly shifting cloudy sky. He appears to have deliberately softened the contour of his gray cloud by adding water along its edges, allowing it to spread and bleed atmospherically into and across the thick, textured watercolor paper. The chimney, topped with a cool brown sun with a glowing yellow center, anchors the mists of Dove's sky with simple geometries. Also enlarged into an oil, *Brown Sun and Housetop* did not translate as directly as did *Sunrise*. The differences between the soft mists of the watercolor and the much more sculptural, hard-edged oil perhaps explain why this type of watercolor is comparatively rare in Dove's output. Unlike the watercolor for *Sunrise*, the watercolor for *Brown Sun and Housetop* gives no indication of the concentric striations of color that define the oil painting. The oil painting, while achieving its own dynamic and solidity, struggles in places to capture the evanescence of the watercolor. This is seen most explicitly in the bottom-most cloud, where the rigid layers that characterized Dove's paintings of this type lose their distinction and overlap each other in what must have been an attempt to capture the flowing, floating quality of the drifting watercolor. The oil and the watercolor were exhibited together in 1937 at An American Place.[89]

Dove often went to sketch at Canandaigua Outlet at the edge of Lake Canandaigua near Geneva. The contrasts in the level of abstraction and color palette among the sketches from the site are striking, and reveal the degree of variation possible in Dove's interpretation of a single place. *Canandaigua Outlet, Oaks Corner*, 1937 (see plate 23), has

a familiar, landscape format, with a foreground, framing trees, and a middle ground that only suggests trees with a single squiggle and a pale blue sky. The colors are basically what we expect in a landscape, brown and green trees, blue sky, and unfortunately muddy brown water, and are typical of Dove's earthy palettes. The trees to the left seem more realistically depicted when seen next to the schematic outline of the trees that line the rest of the image, creating an uncomfortable juxtaposition that probably ruled out enlarging this image. By contrast, *Canandaigua Outlet*, 1938, is entirely non-objective, a series of sweeps of crystal clear pastel yellow, peach, green, pink, and blue gray. Using repeating geometries more freely than in his work of the 1910s and 1920s, *Canandaigua Outlet* of 1938 suggests a close-up view of the churning water of the outlet, perhaps seen on a sunnier day than the one he captured the previous year.

Geometries of the 1940s

Dove's movement toward the flat geometries of his work of the 1940s, seen as early as 1930 in *Swinging in the Park* (see plate 8), is seen again in 1935 in his watercolor *Barns* (see plate 10), one of the numerous images of barns that Dove painted in Geneva. On September 25, 1935, Torr recorded an oblique description in the joint diary she and Dove kept of one of the two watercolors he had done that day: "one a beauty with [nested diamonds] shape in it."[90] If she does not refer to *Barns*, then the nested diamonds motif at the center of this work must have been a favorite motif of the artist that year. The "nested diamonds" form creates one of Dove's most radically simplified and structured depictions of a barn, converting the angles of pitched roofs, which soar or sag in gentle curves in other images, into regular, balanced geometries. The colors of one of Dove's favorite palettes of olive greens, browns, and yellow-ocher, set off by blue-gray, are used heavily enough to stress the weight of the forms under their black outlines. Unlike his more common approach to watercolor, Dove may have blocked in the colors of this painting before adding these outlines, which run on top of the other colors bleeding into the blue-grays in some places. With a diamond for a barn, a small green circle suggesting a tree, or more likely in Dove's visual vocabulary, the sun or moon, and the rising sun perhaps signaled by the rim of

yellow around the top of the brown barn, this is a reductive, conceptual work that foreshadows the artist's flat, geometric style of the late 1930s and 1940s.

As the artist was confined to bed periodically from 1938 until his death in 1946, Dove's watercolors and sketches from this period have two sources. Many of his "ideas for paintings" were still gathered from walks outdoors, as they always had been, or, when he was confined to his home, from the porch, window, or glass studio of the little house in Centerport. "Made four watercolors yesterday," he recorded in a letter to Stieglitz, "and one in bed at night. Don't know whether it is Vitamins or Spring."[91] Increasingly though, Dove found himself able to create without an immediate source in the natural world. In the 1910s he had rejected the idea of working without a grounding in nature, telling Stieglitz that he had tried it and it had caused his line to go dead.[92] After a quarter century of picture making, however, Dove discovered in the 1940s, perhaps out of necessity, that he could work from ideas and his memories of the landscape alone. While some of Dove's work of the 1940s remained based in the landscape even as it became flatter and more structured,[93] other works have a more ambiguous, perhaps only conceptual relationship to the natural world. Dove also revisited old visual themes and problems in the 1940s, reinterpreting them in his new, simplified geometries.[94]

Dove's watercolors had always depended on isolated strokes of color used independently of any modeling or interaction with adjacent shades. In the 1930s Dove's oil and wax emulsion paintings had only partially imitated this effect, often placing different shades of the same color next to each other in bands. Color variations within each form become much less frequent in his geometric oil paintings of the 1940s, however, possibly an attempt to come closer to the effect of the unmodulated colors in the watercolors. The small wax emulsion and tempera sketches would have further encouraged this shift, as they also rarely display traditional modeling, perhaps also influenced by this quality of the watercolors. Dove often gave his wax emulsion and tempera sketches more of the weight of full-size paintings than the watercolors had, by creating solid, flat, opaque, fully colored forms, rather than alluding to a colored shape with a single outlining sweep of watercolor. The gouache *Arrangement from Landscape*, 1941 (see plate 12), adopts the technique he used for sketches in heavier paints to watercolor, merging the two.

Dove's watercolors of the early 1940s show him moving away from his organic, flickering style of the 1930s toward the geometry and solid blocks of color that dominated his work in the mid-1940s. *Landscape in Four Flats*, 1940, appears to sit between these two stylistic variations. The oval at the center of *Landscape in Four Flats* is Dove's usual symbol for a willow tree. Here it may suggest a cluster of leaves on a branch, but more probably it is a willow, seen across the gray water, just past a strip of beige, speckled beach. This willow radiates almost like Dove's suns of the mid-1930s, with layers of greens and yellow spreading around the brown trunk, all set against a steel-blue sky. While the centralized, radiating composition is reminiscent of the structure of many of Dove's earlier works, this painting lacks the overlapping colors that created the glow in Dove's celestial images of that period. The heaviness of the paint, and its application in unmodulated, matte layers that do not allow light to pass through, are entirely of the period of its execution, when flat areas of color were becoming prevalent in Dove's work; hence the "four flats" of the title.

Like *Landscape in Four Flats*, the works *Untitled 1, Centerport*, c. 1940 (plate 30), and *Out the Window*, 1940 (see plate 11), rely on a traditional definition of landscape space, while exploring different approaches to more geometric abstraction. The basic structure of these two works, anchored by a layer of water or ground occupying the bottom quarter of the canvas, while the majority of the landscape elements interact above, is typical of Dove's landscape compositions of the 1930s and of some of his works of the early 1940s. *Out the Window* is one version of the view from Dove's Centerport home. The stripe of water at the bottom is topped by an almost hieroglyphic or totemic representation of the shapes thrown against the sky on the other side of the millpond. The horizontal and diagonal lines that tie together the disparate symbols of this composition break up the surface into the geometric sections typical of his work in this period. *Untitled 1, Centerport* may be another version of this same view. Instead of reducing the forms across the water to succinct, static signs, as in *Out the Window*, in this watercolor Dove looks back to freely drawn images of the 1930s like *Untitled* (see plate 9). Conveying a sense of the dynamic of the landscape, the Surrealist, organic line in *Untitled 1, Centerport* is not seen often in Dove's larger works of the 1940s but is used here with fewer concrete landscape references than in his large paintings of the 1930s.

Dove attempted to capture some of the surface effects of the original watercolor again in his 1940 *No Feather Pillow*. In the watercolor (plate 31) washes of color cover the entire surface of the composition, which seems to be suspended between his radiant celestial paintings of the mid-1930s and the hard-edged, interlocking, flat geometries of much of his work of the 1940s. These washes, however, reveal abundant flickers of white paper, creating textural interest and vibration. The greenish-gray serrated form moving toward the upper right of the image in the larger painting is spotted with tiny dots of the tan below it, each one backed by black. The spots break up the surface in the same way that the flecks of revealed paper do in the watercolor. The green brushstrokes at the bottom center of the painting also correspond to this aspect of the watercolor. These effects may well be intentional references to the incomplete coverage of the paper provided by drier washes of watercolor. The layering of color in this painting is also unusual for Dove and may be another attempt to imitate the transparent washes of watercolor. The diagonal strokes of greenish yellow paint in the upper left of the wax emulsion painting are particularly transparent and suggestive of the layering of watercolor washes. Dove did eliminate the heavy outlines of the watercolor in the final painting, but he left clear edges between forms. While the circular form in *No Feather Pillow* may suggest that this is a variation on the sky, it is so far removed from any possible natural source that it may be considered an essentially non-objective painting, a new mode for Dove in the 1940s.

Landscape remained an important part of Dove's inspiration and his imagery in the 1940s, however, coexisting in his oeuvre with more non-objective paintings. The range possible in Dove's allusions to the landscape in the early 1940s is reinforced by comparing two of his small works of 1941, the watercolor *Untitled Centerport #2* (plate 33) and the gouache *Arrangement from Landscape* (see plate 12). Between the two images, these works contain virtually all of the stylistic innovations of Dove's larger paintings of the 1940s, among them the rejection of traditional landscape space, the angularity of interlocking geometries, and the introduction of vibrant color.

Even more so than *Untitled 1, Centerport*, the colors and forms of *Untitled Centerport #2* seem to explode to activate the entire sheet of paper. With its peaked horizon line and vibrant purples, yellows, and oranges, the image suggests autumn foliage or a sunset, but it has moved away from the pulsating, mystical orbs of Dove's celestial images of the

1930s, such as *Sunrise*, 1937 (see plate 14), into a hard-edged dynamism. Its slashing lines and the jagged shapes that they define are more aggressive and monumental than the forms in his more intricate organic landscapes. Angularity and lack of recessional space became increasingly common in Dove's work of the 1940s. While *Untitled Centerport #2* retains the low horizon line so often part of Dove's landscapes, *Arrangement from Landscape* discards even this compositional device. None of the lines that might suggest a horizon continues to the left edge of the paper, leaving the image ungrounded, floating in space, like so many of Dove's completely abstract paintings of the 1940s. Without the title, the viewer would be hard pressed to identify this work as derived from a landscape. This image retains vestiges of his earlier work in its undulating, swelling line, which traverses the entire surface while refusing to define, or even suggest, a recognizable subject matter. Its biomorphic, opaque forms recall the fantasies of Klee and abstract Surrealism. It further seems to carry the seed of Dove's patterning of geometries in the pocket of intersecting blue, green, and brown triangles just left of center, nestled in the curves that dominate the composition. Only its color scheme ties this gouache to the landscape. Its browns, greens, blues, and pink compose an earthier palette than that of *Untitled Centerport #2*.

These two paintings also demonstrate the extremes in Dove's use of paint in the 1940s. The gouache in *Arrangement from Landscape* is flat, relatively solid and opaque, and contained by the ink line that determines the composition. By contrast, Dove has given the transparent watercolor in *Untitled Centerport #2* its own independent life. It pools and spreads, soaks into the paper, and runs across the surface, often in disregard of the defining lines of black ink. This watercolor almost appears to be an experiment in the textural possibilities of the medium as Dove alternately drips on violet and forest green, carefully brushes on a light yellowish ocher, and allows the orange to glide and spread seemingly uncontrolled by the artist. More violet dabbed on top of brown with the flat tip of the brush, the smudge of a yellow fingerprint, and a triangle of black paint so wet and agitated that it bubbles, add further to the abundance of textures in this image.

Untitled #12, 1941, provides an example of how Dove used his sketches in the 1940s to revisit old subject matter and explore new possibilities for it. This tiny, jewel-toned image combines, almost schematically, three of Dove's most common motifs of the 1930s

and 1940s. The diamond on the left is, of the three elements, the newest addition to his artistic vocabulary, the "square on the pond" that represented the buildings on the shore opposite the Doves' home in Centerport. The middle figure in this work is unmistakably another variation of Dove's celestial suns, developed most dramatically in the mid-1930s, but here reintegrated and restated in the more rectilinear, geometric vocabulary of Dove's work of the 1940s, almost totemically reflected in the smooth harbor. The deep green circle on the right, geometrically countering the tipped square on the left, is one of Dove's common interpretations of the willow trees he and Reds so loved. The soft halos of color that defined Dove's attempts to paint radiating light and blowing trees in the 1930s had dropped out by 1940 or 1941, replaced with solid, unmodulated fields of color, which anticipate the painting of the 1950s and 1960s. This treatment is also seen in *Arrangement from Landscape*, 1941.

The Hand Sewing Machine (plate 32), dated 1941, is an almost lyrical restatement of an old familiar subject, executed in a style more similar to that of his watercolors of the early and mid-1930s than to that of his more recent works. The subject recalls his important collage of 1927, also titled *Hand Sewing Machine*, and is simultaneously an homage to and evocation of his wife, the user of the sewing machine. The indoor subject is also testimony to his restricted mobility. Still life had not been an important genre for Dove since he left France in 1909. His collages of the *Hand Sewing Machine* and *Grandmother*, 1925, are his only major works that resemble traditional, interior still lifes. He did, however, do at least one gouache entitled *Abstract Still Life* in 1941, a Cubist version of fruit on a table. In general, when Dove painted objects they were objects in and of the outdoors: harbor machinery, a lantern, an outboard motor, an awning. The traditional still life may have been too classically French for Dove to embrace it purely on an ideological basis. The collage *Hand Sewing Machine* of 1927, to which the watercolor refers, is itself influenced by the mechanized imagery of Marcel Duchamp and Picabia, by Dadaist and Cubist collage, and by the Precisionist imagery of American artists like Morton Schamberg, Charles Sheeler, and Charles Demuth.[95] It encapsulates a particularly rich moment in American modernism, one twenty years before Dove revisited the sewing machine in watercolor. His reuse of that subject may be a nod not only to his own past work, but to the era as a whole. The style of the watercolor, with

delicate outlines echoed by sweeping strokes of watercolor that leave the inside of several of the forms untouched by paint, resembles that of earlier works such as *Distraction*, 1928 (see plate 6), *Abstraction, Autumn Leaves,* 1938 (see plate 22), and *Canandaigua Outlet, Oaks Corner*, 1937 (see plate 23). It also reveals the impact of his recent sketches in gouache and tempera in the more thoroughly painted-in areas of the upper half of the composition. Evocative of both previous and contemporary work, and alluding obliquely to the artist's wife, *The Hand Sewing Machine* is a sentimental watercolor,

Figure 6. Arthur Dove. *Untitled from Sketchbook "E."* c. 1940–46.
Graphite and colored pencil on machine-made wove paper, 3 x 4 $^1/_{16}$ in.
The Arkansas Arts Center Foundation Collection, Little Rock

confronting Dove's relationship to his art and life, rather than his relationship to nature.

Untitled Sketch (Study for Green and Brown), 1945 (see plate 7), is also removed from nature, but it is not so seemingly personal in its sentiment. This watercolor is the source of Dove's oil entitled *Green and Brown*, 1945. Some of the lines in the watercolor are eliminated in the oil, but even the thinner, more delicate lines that remain vary in width in accordance with the variations in the outlines of the watercolor. While in this instance Dove generally smoothed out the textural variations of the watercolor in the oil, he retained the unevenness of the watercolor in the heavily brushed highlight on the left. While the colors suggest the natural world, *Green and Brown* reflects Dove's preference at the time to work more from ideas and memories than from a viewed landscape. Another late watercolor, *Untitled from Sketchbook "E" (Red, green, and blue rectangles)*, c. 1940–46 (plate 34), suggests a connection to Dove's 1943 wax emulsion, *Rooftops* in its stacking of overlapping rectangles. The visual texture of the wax emulsion, in which Dove's usually flat blocks of color appear scrubbed or washed with black, may have been an attempt to retain some of the mottling of the watercolor.

Watercolor, wax emulsion, and tempera paints were not the only mediums in which Dove executed his sketches. He used virtually any source of color available to him, filling sketchbooks with "ideas for paintings" or just visual notations in colored pencil and even crayon. *Untitled from Sketchbook "E,"* c. 1940–46 (figure 6), is a work in graphite and blue, brown, and yellow colored pencil. While not the direct source of a larger painting, it is related to a variation of Dove's generally geometric style of the 1940s in which he combined discrete geometric shapes with looping or zigzaging black lines, all set against a solid background, as in *.04%*. The figure on ground distinction is stronger here than in Dove's other works of the 1940s, heightening the connection to his earlier landscape images initially suggested by the looping line first seen in *Violet and Green*. This stylistic variation dates only to 1942 and 1943, and may suggest a date for Sketchbook "E," or at least for this image. All of Dove's stylistic developments found expression in his sketches.

Dove's pastels have long been recognized as major works and as an important landmark in American modernism, but they have often been discussed as if they were oil paintings. While Dove considered these works the equivalent of paintings, their medium

62

was a significant factor in their own formal qualities and in the development of Dove's oil painting. The light-absorbing texture of pastel provided Dove with his first viable alternative to the reflective quality of oil. The experiments with paints and materials that characterized the rest of his career may be seen as an attempt to achieve other surfaces that successfully captured light. Dove's use of watercolor from 1928 to 1946 may be seen as part of this search for a medium that allowed light to travel through it, but other of its qualities were more important to the artist. Watercolor's portability and its rapid execution made it ideal for capturing the instantaneous impression or idea, whether it occurred in the studio or on the lake. Dove recognized the practicality of the medium, and the potential for the luminous fluidity of watercolor to suggest formal effects for his oil paintings. Watercolor became a crucial part of the artist's working process in these last two decades of his career, allowing him to experiment with images, stylistic developments, and the ideas of others before incorporating them into his established, individual style. His watercolors were also an important part of his public presentation in these years, shown in abundance at his annual exhibitions and included in significant numbers in other shows of his work, and even in group exhibitions. In the context of the American revivals of pastel and watercolor, Dove's works assert their stylistic independence even while his use of the mediums supports the common ideals of all the artists who participated: the equality of artistic mediums and, in the case of the revival of watercolor, the creation of a distinctly American artistic tradition. Dove's pastels and watercolors were essential components of his work.

Notes

1. Alfred Stieglitz, quoted in Dorothy Norman, "Writings and Conversations of Alfred Stieglitz," *Twice a Year* no. 1 (Fall-Winter 1938): 79.

2. Dove's life and his work, predominantly his oils and pastels, have been discussed and documented in Frederick S. Wight, *Arthur G. Dove* (Berkeley and Los Angeles: University of California Press, 1958), Barbara Haskell, *Arthur Dove* (San Francisco: San Francisco Museum of Art, 1974), Ann Lee Morgan, *Arthur Dove: Life and Work, With a Catalogue Raisonné* (Newark, Del.: University of Delaware Press, 1984), and Debra Bricker Balken, William C. Agee, and Elizabeth Hutton Turner, *Arthur Dove: A Retrospective* (Cambridge, Mass.: The MIT Press, 1997).

3. There is an enormous amount of literature on Whitman, Thoreau, and Emerson and the arts of the early twentieth century. For example, see Geoffrey M. Sill and Roberta K. Tarbell, eds. *Walt Whitman and the Visual Arts* (New Brunswick, N.J.: Rutgers University Press, 1992).

4. Morgan, 1984, 46 and "An Extract From Bergson" (from *Creative Evolution*, by Henri Bergson) *Camera Work* 36 (October 1911): 20.

5. See Gail Levin and Marianne Lorenz, *Theme and Improvisation: Kandinsky & the American Avant-Garde 1912–1950* (Boston: Little, Brown and Company, 1992) and Gail Levin, "Wassily Kandinsky and the American Avant-Garde, 1912–1950" (Ph.D. dissertation, Rutgers University, 1976) for a more thorough discussion of Kandinsky's influence on Dove and his contemporaries.

6. For specific discussion of Dove's collages, see Dorothy Rylander Johnson, *Arthur Dove: The Years of Collage* (College Park, Md.: University of Maryland Art Gallery, 1967).

7. Elizabeth Hutton Turner, "Going Home: Geneva, 1933–1938," in Balken et al., 101.

8. Duncan and Marjorie Phillips amassed numerous oils and watercolors, most now in the Phillips Collection in Washington, D.C. The Phillips's watercolors are the most thoroughly published of Dove's watercolors and can be found in Sasha M. Newman, *Arthur Dove and Duncan Phillips: Artist and Patron* (Washington D.C.: The Phillips Collection in association with George Braziller, Inc., New York, 1981) and Elizabeth Hutton Turner, *In the American Grain: Arthur Dove, Marsden Hartley, John Marin, Georgia O'Keeffe, and Alfred Stieglitz: The Stieglitz Circle at the Phillips Collection* (Washington D.C.: Counterpoint in association with the Phillips Collection, 1995).

9. Charles C. Eldredge, *Reflections on Nature: Small Paintings by Arthur Dove 1942–1943* (New York: The American Federation of Arts, 1997): 13.

10. See Eldredge for a discussion of Dove's small wax emulsion, tempera, oil, and watercolor sketches.

11. These revivals are well documented in Doreen Bolger et al., *American Pastels in the Metropolitan Museum of Art* (New York: The Metropolitan Museum of Art, 1989) and Sue Welsh Reed and Carol Troyen, *Awash in Color: Homer, Sargent, and the Great American Watercolor* (Boston: Museum of Fine Arts, Boston, in association with Bulfinch Press, Little, Brown and Company, 1993).

12. Mary L. Sullivan, "The Society of Painters in Pastel and the International Revival of the Medium," in Bolger, 6.

13. Victor Koshkin-Youritzin, *American Watercolors from the Metropolitan Museum of Art* (New York: The American Federation of Arts in association with Harry N. Abrams, Inc., Publishers, 1991): 19.

14. Sullivan, 11.

15. Mary Wayne Fritzsche and Gail Stavitsky, "Pastel and the American Modernists," in Bolger, 22.

16. Elizabeth Wylie, "Illustrators, the Eight, and Pastel," in Bolger, 18.

17. Fritzsche and Stavitsky, 25.

18. Doreen Bolger, "The Pastellists, 1910–15," in Bolger, 20–21.

19. "First Exhibition of 'The Pastellists' Suggests the Revival of a Charming Form of Eighteenth Century Art," *The New York Times*, January 15, 1911, section 5, p. 15. See Bolger, 20, 30.

20. Carol Troyen, "A War Waged on Paper: Watercolor and Modern Art in America," in Reed and Troyen, xxxvi, and Marilyn Kushner, *The Modernist Tradition in American Watercolors 1911–1939*. (Mary and Leigh Block Gallery, Northwestern University, 1991): 15.

21. Kushner, 10–11.

22. Ibid., 10–11, 14–15.

23. Troyen, xxxvii–xxxviii, discusses exhibitions of modernist watercolors in New York at this time; Kushner, 12–13 also discusses the importance of Stieglitz in the promotion of works on paper. All of the exhibitions arranged by Stieglitz are listed in Appendix II of Sue Davidson Lowe, *Stieglitz: A Memoir/Biography* (London: Quartet/Or! Books, 1983): 429–37.

24. Troyen, xxxvi.

25. Samuel Swift in the *New York Sun*, reprinted in *Camera Work* 42–43 (April–July 1913, published in November 1913): 48.

26. Troyen, xxxv.

27. Paul Strand, "American Water Colors at the Brooklyn Museum," *The Arts*, 2 (December 1921): 151.

28. Troyen, xxxv.

29. Holger Cahill, *Modern American Water Colors Shown at the Newark Museum*, January 4–February 9, 1930 (Newark, N.J.: The Newark Museum, 1930): 8.

30. Dove quoted in Frederick S. Wight, *Arthur G. Dove* (Berkeley and Los Angeles: University of California Press, 1958): 62.

31. Barbara Haskell, "Georgia O'Keeffe: Works on Paper, A Critical Essay," in Museum of Fine Arts, Museum of New Mexico, Santa Fe, *Georgia O'Keeffe: Works on Paper* (Santa Fe: Museum of New Mexico Press, 1985): 2–3.

32. Sarah Whitaker Peters, *Becoming O'Keeffe: The Early Years* (New York: Abbeville Press, Publishers, 1991): 109–10.

33. William Innes Homer, "Identifying Arthur Dove's 'The Ten Commandments'," *American Art Journal* 12 no. 3 (Summer 1980): 21–32.

34. The critical response to Dove's exhibitions of *The Ten Commandments* is discussed in Wight, 29–33; Ann Lee Morgan, "'A Modest Young Man with Theories': Arthur Dove in Chicago, 1912," in Sue Ann Prince, ed., *The Old Guard and the Avant-Garde: Modernism in Chicago, 1910–1940* (Chicago: University of Chicago Press, 1990): 23–38; and in Deborah Bricker Balken, "Continuities and Digressions in the Work of Arthur Dove from 1907 to 1933," in Balken et al., 17–35, p. 22.

35. Paul Rosenfeld, *Port of New York* (Harcourt, Brace and Company, Inc., 1924; reprint, Urbana: University of Illinois Press, 1961): 171.

36. I am grateful to Elizabeth Hutton Turner for sharing her ideas about the importance of Dove's use of various paints and materials with me.

37. Dove letter to Samuel Kootz, written in 1910s, for Kootz, *Modern American Painters*, 1930. Reprinted in Barbara Haskell, *Arthur Dove* (San Francisco: San Francisco Museum of Art, 1974): 134.

38. Morgan, 1984, 58.

39. Rosenfeld, 169.

40. Matthew Baigell, "Walt Whitman and Early Twentieth-Century American Art," in Sill and Tarbell, eds.: 121–41, p. 130.

41. Dove to Stieglitz, June 20 or 21, 1928; Ann Lee Morgan, *Dear Stieglitz, Dear Dove* (Newark: University of Delaware Press, 1988): 150.

42. Marjorie Shelley, "American Pastels of the Late Nineteenth & Early Twentieth Centuries: Materials and Techniques," in Bolger, 39.

43. Ibid., 35.

44. Dove to Stieglitz, February 1, 1932; Morgan, 1988, 237.

45. Ibid., June 20 or 21, 1928; Morgan, 1988, 150.

46. Judith Zilczer, "Synaesthesia and Popular Culture: Arthur Dove, George Gershwin, and the 'Rhapsody in Blue,'" *Art Journal* 44 (Winter 1984): 361–66, p. 361.

47. Donna M. Cassidy, "Arthur Dove's Music Paintings of the Jazz Age," *American Art Journal* 20 no. 1 (1988): 10.

48. Morgan, 1984, 53.

49. Eldredge, 11.

50. Elizabeth Hutton Turner made this observation in a conversation regarding her fall 1997 Dove watercolor exhibition.

51. Dove to Stieglitz, October 1, 1935; Morgan, 1988, 341.

52. Dove to Stieglitz, probably May 25, 1936; Morgan, 1988, 353.

53. Dove to Elmira Bier, assistant to Duncan Phillips, late December 1933 or early January 1934, the Phillips Collection Archives; Turner, "Going Home: Geneva, 1933–1938" in Balken et al., 95–113, p. 112.

54. Suzanne Mullett Smith Papers, Archives of American Art, microfilm reel 1043, frame 579.

55. Dove to Stieglitz, August 1932; Morgan, 1988, 249.

56. Ibid., August 9, 1932; Morgan, 1988, 245.

57. Ibid., July 5, 1931; Morgan, 1988, 227.

58. Turner, 1997, 101.

59. Diary; May 24, 1935; Arthur and Helen Torr Dove Papers, Archives of American Art, microfilm reel 39, frame 108.

60. Ibid., June 9, 1935; reel 39, frame 116.

61. Ibid., June 10, 1935; reel 39, frame 116.

62. Turner, 1997, 102.

63. Dove to Stieglitz, November 15, 1933; Morgan, 1988, 288.

64. Dove's son, William Dove, called the projector a "magic lantern" in an interview with Anne Cohen DePietro, "A Form Finding a Form," in Anne Cohen DePietro, et al., *Arthur Dove & Helen Torr: The Huntington Years* (Huntington, N.Y.: The Heckscher Museum, 1989): 78.

65. Dove to Stieglitz, September 3, 1931; Morgan, 1988, 230–31.

66. Diary; January 26, 1935; Arthur and Helen Torr Dove Papers, Archives of American Art, microfilm reel 39, frame 236.

67. Ibid., February 10–11, 1936; reel 39, frames 299–300.

68. Turner, 1997, 104.

69. Eldredge has suggested that the wax emulsion sketches were used less often than the watercolors as preliminary studies because they would not have withstood the heat of the projector well. Eldredge, 22.

70. Unlike his treatment of the somewhat larger watercolors, Dove seems rarely to have sold or given away these small sketches. Vast numbers of them remained in the possession of the artist's son, William Dove, until the 1980s when he donated them in groups of approximately twenty to thirty to museums throughout the country to complement their Dove collections. This suggests that Dove conceived of the watercolors as having a more independent existence than the smaller sketches.

71. Dove to Stieglitz, March 28, 1932; Morgan, 1988, 239–40.

72. Edward Alden Jewell, "Dove Gives Annual Exhibition," *The New York Times*, March 11, 1931, p. 20.

73. Exhibition checklist, Dove Papers, Archives of American Art, microfilm reel N70-51, frame 311.

74. Stieglitz to Dove, June 8, 1934; Morgan, 1988, 310.

75. The cards in Suzanne Mullett (Smith)'s card file for the following watercolors note that they were exhibited at the Springfield Museum of Art in 1933. She also provides their checklist numbers for that show, provided here in parentheses, suggesting that she was basing these notes on something more concrete than Dove's, Stieglitz's or McCausland's memory of the exhibition. *Harbor with Red Buoy*, 1932 (#1), *Steam Shovel, Port Washington*, 1932 (#2), *Colored Drawing*, 1932 (#4), *Dogwood*, 1931 (#5), *Sketch for Painting Only*, 1932 (#6), *Sycamore*, 1931 (#7), *McKesson Brown Boat House*, 1931 (#8), *Sea Gulls*, 1932 (#10), and *Wednesday Snow*, 1933 (#11). Suzanne Mullett Smith Papers, Archives of American Art. Microfilm Roll 1043.

76. Duncan Phillips, "Retrospective Exhibition of Works in Various Media by Arthur G. Dove," March 23–April 18, 1937, Phillips Memorial Gallery, Washington, D.C.

77. Quoted in Elizabeth McCausland, "Dove: Man and Painter," *Parnassus* (December 1937): 3–6.

78. Dove letter to Samuel Kootz, reprinted in Haskell, 134.

79. Turner, 1997, 102.

80. Morgan, 1984, 58.

81. *Beach Umbrellas* (plate 25), dated 1931 on a Stieglitz label affixed to its back, is in the more common, smaller size. It is possible that this label is incorrect, as the smaller works proliferated in 1932, or, more probably, that it is an early example of the smaller format.

82. Suzanne Mullett Smith Papers, Archives of American Art, microfilm reel 1043, frame 715.

83. Ibid., frame 605. This catalog entry, made on March 26, 1943, notes that the work is in the Lincoln warehouse, has no signature on the front, and is signed, dated July 1930, and numbered #3 on the back. It includes a sketch that clearly shows the foliage at the top and the form of the swinging figure. The oil painting to which this sketch corresponds is unpublished.

84. Ibid., frame 961.

85. Between 1939 and 1942 Dove made ten watercolors of the Franciscan Brothers Monastery across Centerport Harbor from his home. They are all considered studies for his large paintings of the same subject in 1941 and 1942. The watercolors are all owned by the McNay Art Museum; Agee, "New Directions: The Late Work, 1938–1946," in Balken et al., 133–153, pp. 136–37.

86. Suzanne Mullet Smith Papers, Archives of American Art, microfilm reel 1043, frame 964.

87. The watercolor of *Sunrise* is currently dated 1937. The wax emulsion and oil painting *Sunrise III*, is dated 1936. As these works are clearly related and there are no documented instances, or even suggestions, of Dove's doing a watercolor after a preexisting oil, one of these dates is most likely incorrect.

88. Marjorie B. Cohn has noted another instance of Dove's adapting watercolor effects to oil in his imitation of the diffusion of two colors of watercolor into each other in *Gas Tank and Building*, 1938, in the oil painting *Tanks*, 1938. Marjorie B. Cohn, *Wash and Gouache: A Study of the Development of the Materials of Watercolor* (Boston: The Center for Conservation and Technical Studies, Fogg Art Museum and The Foundation of the American Institute for Conservation, 1977), 39.

89. Suzanne Mullett Smith Papers, Archives of American Art, microfilm reel 1043, frames 903, 904.

90. Diary; September 25, 1935; Arthur and Helen Torr Dove Papers, Archives of American Art, microfilm reel 39, frame 170.

91. Dove to Stieglitz, April 14, 1942; Morgan, 1988, 468.

92. Hutchins Hapgood, "The Live Line," *The Globe and Commercial Advertiser* (New York), 8 March 1913, p. 7, quoted in Wight, 37.

93. See Agee, in Balken et al., 134–53, for an analysis of Dove's stylistic development in the 1940s.

94. Eldredge, 13.

95. The most recent discussion of the impact of these artists on Dove can be found in Balken et al., 29–31.

PLATES

Movement No. 1

c. 1911, pastel on canvas, 21 3/8 x 18 in.
Columbus Museum of Art, Ohio

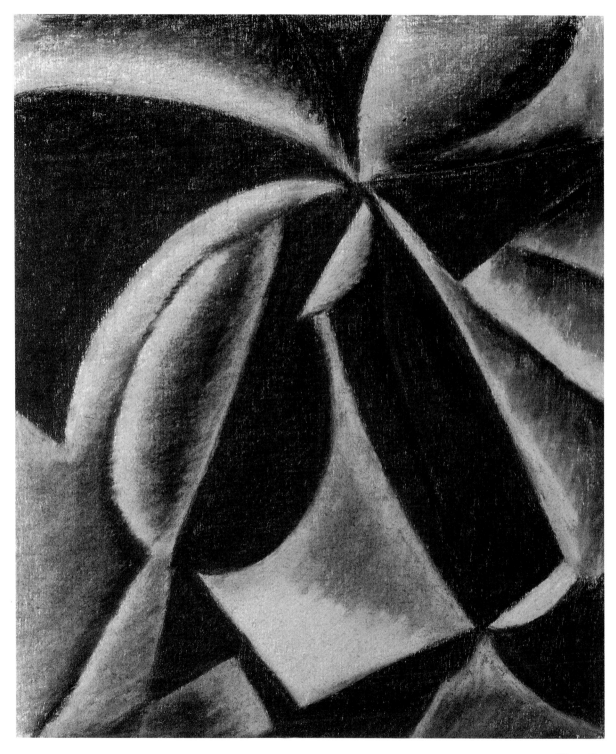

Plate 1

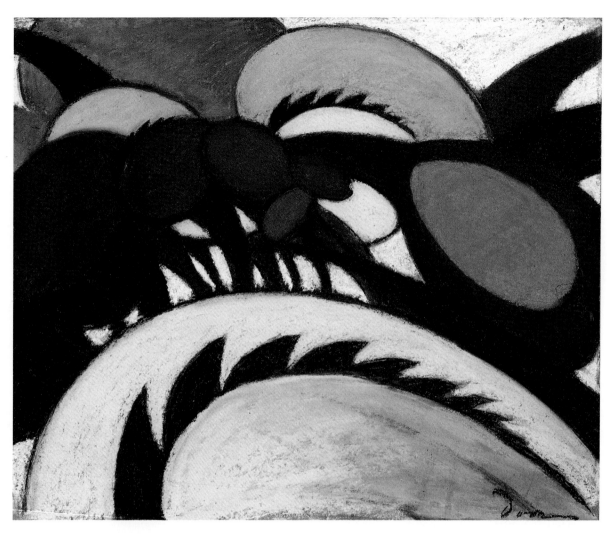

Plate 2

Team of Horses

1911 or 1912, pastel on composition board, 18 1/8 x 21 1/2 in.
Amon Carter Museum, Fort Worth, Texas

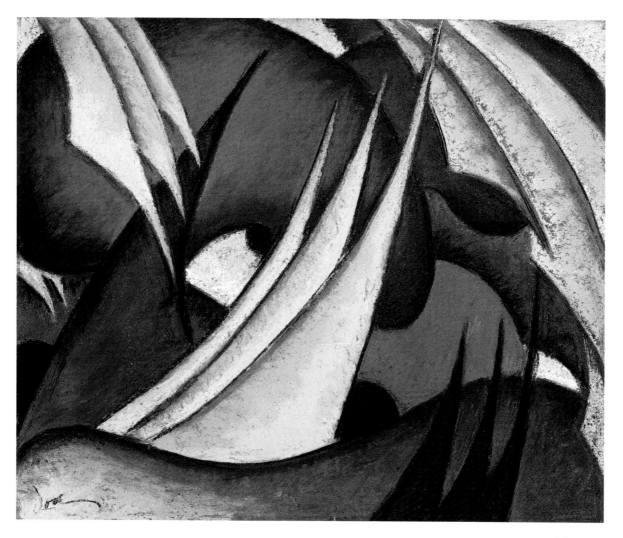

Plate 3

Sails

1911–12, pastel on composition board mounted on panel,
17 $^7/_8$ x 21 $^1/_2$ in. Terra Foundation for the Arts, Chicago

Sentimental Music

1917, pastel on gray paper, mounted on plywood, 21 ¼ x 17 ⅞ in.
The Metropolitan Museum of Art, New York

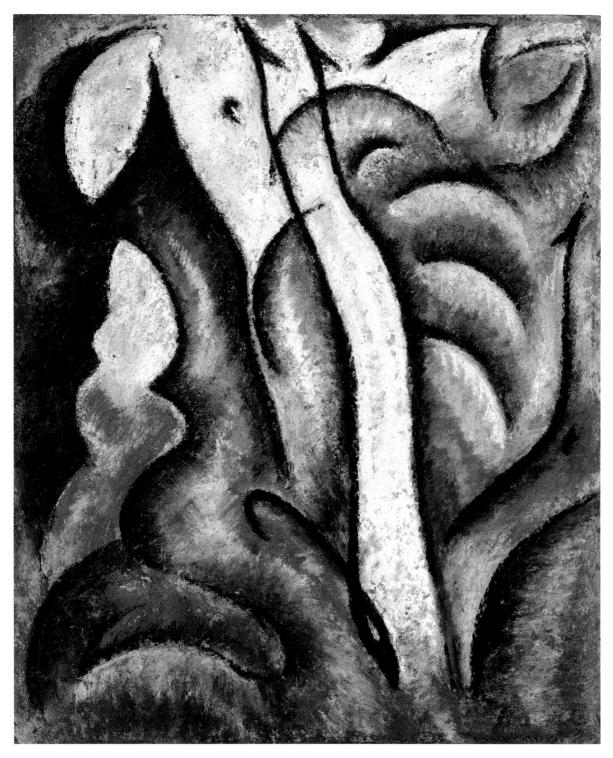

Plate 4

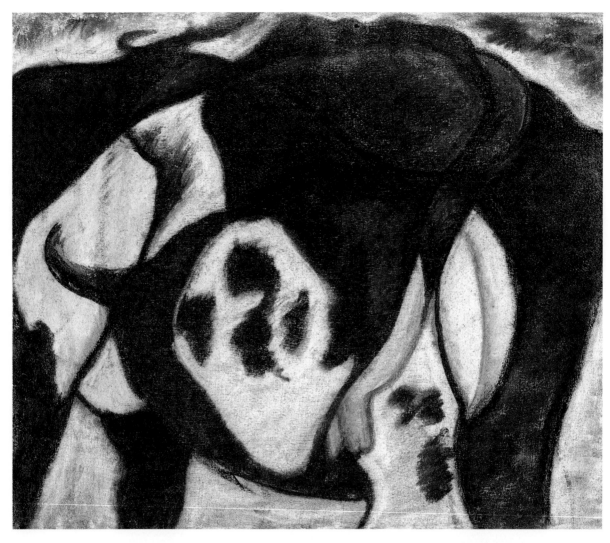

Plate 5

Cow

c. 1911, pastel on linen, 18 x 20 ⅝ in.
The Metropolitan Museum of Art, New York

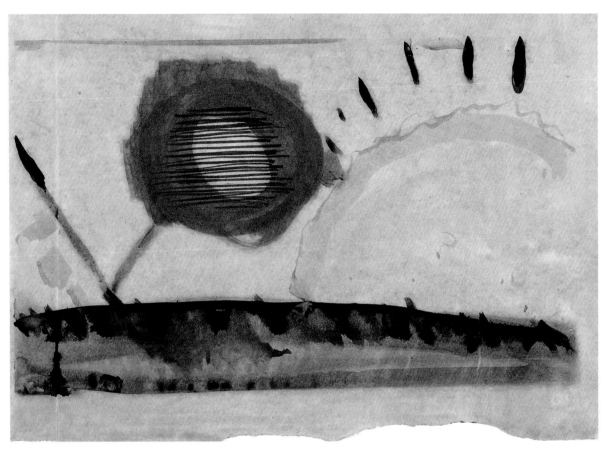

Plate 6

Distraction

1928, brush and black ink and watercolor, 8 9/16 x 12 1/8 in.
National Gallery of Art, Washington, D.C.

Plate 7

Untitled Sketch
(Study for Green and Brown)

1945, oil, watercolor, and ink on paper, 3 x 4 in.
Amon Carter Museum, Fort Worth, Texas

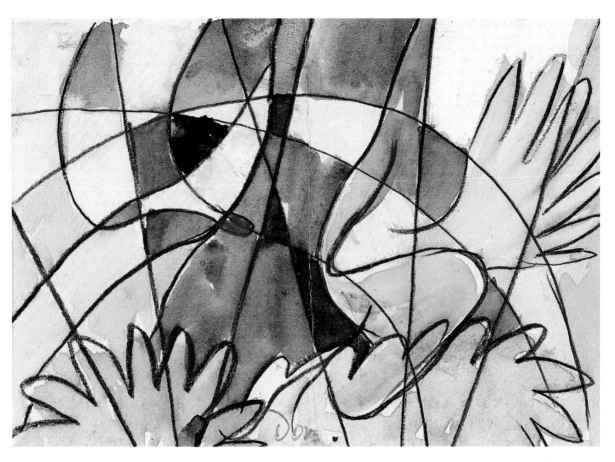

Swinging in the Park

1930, watercolor, 4 5/8 x 6 3/4 in.
Colby College Museum of Art, Waterville, Maine

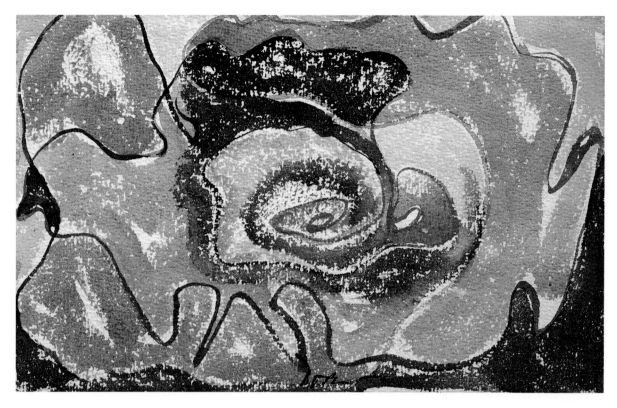

Plate 9

Untitled

no date, watercolor and ink on paper, 5 x 6 $^3/_4$ in.
Collection of Mr. and Mrs. John B. Rehm

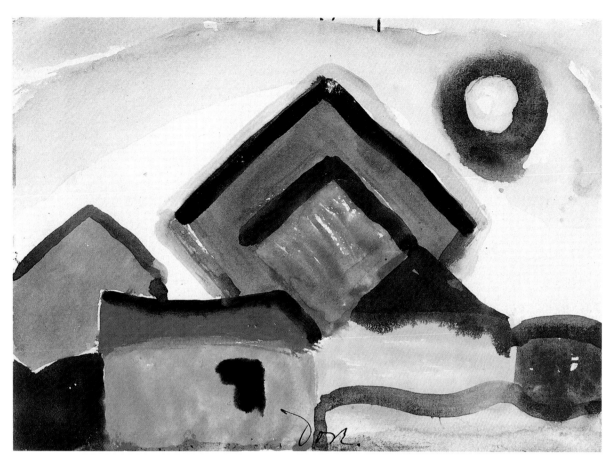

Plate 10

Barns

1935, watercolor on paper mounted on cardboard, 5 $\frac{1}{16}$ x 7 in.
Carnegie Museum of Art, Pittsburgh

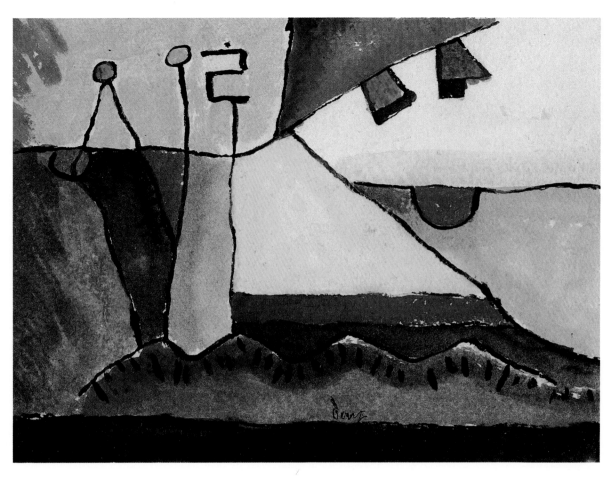

Plate 11

Out of the Window

1940, watercolor on paper, 5 x 7 in.
Sheldon Memorial Art Gallery, University of Nebraska-Lincoln

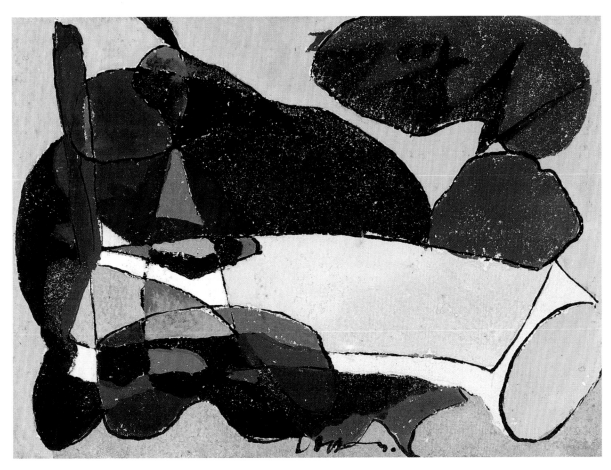

Plate 12

Arrangement from Landscape

1941, gouache and ink on paper, 5 x 7 in.
Heckscher Museum, Huntington, New York

Plant Forms

c. 1912, pastel on canvas,
17 1/4 x 23 7/8 in.
Whitney Museum of American
Art, New York

86

Plate 13

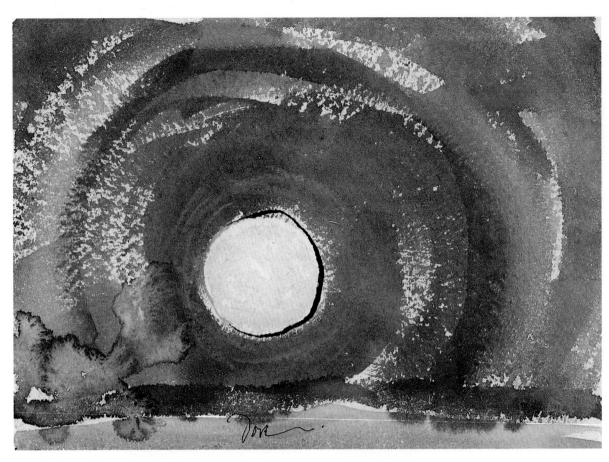

Plate 14

Sunrise

1937, watercolor on paper, 5 x 7 in.
Wadsworth Atheneum, Hartford, Connecticut

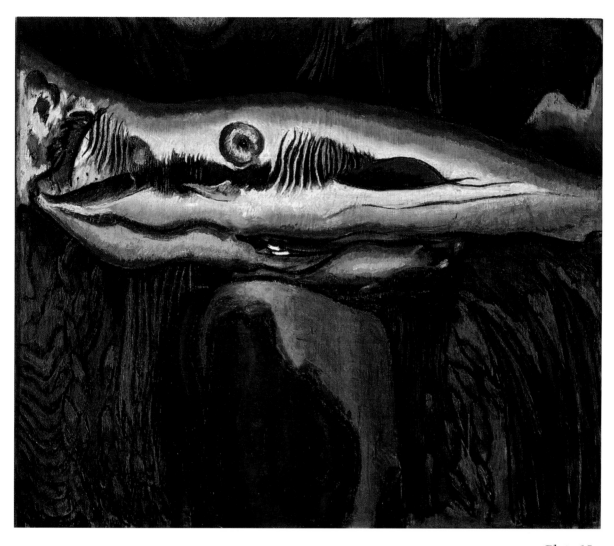

Plate 15

Tree Forms

1928, pastel on wood, 26 x 31 in.
Carnegie Museum of Art, Pittsburgh

Yachting

c. 1912, pastel on canvas,
18 x 21 ½ in.
Museum of Fine Arts, Boston

90

Plate 16

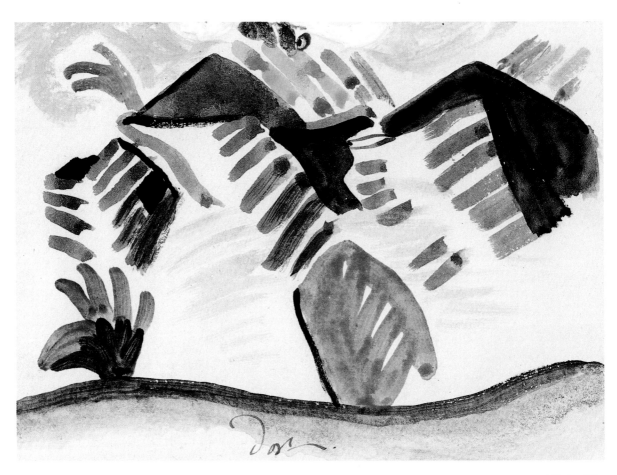

Plate 17

Falling Shed Roof

1934, watercolor on paper mounted on board, 4 7/8 x 6 7/8 in.
Carnegie Museum of Art, Pittsburgh

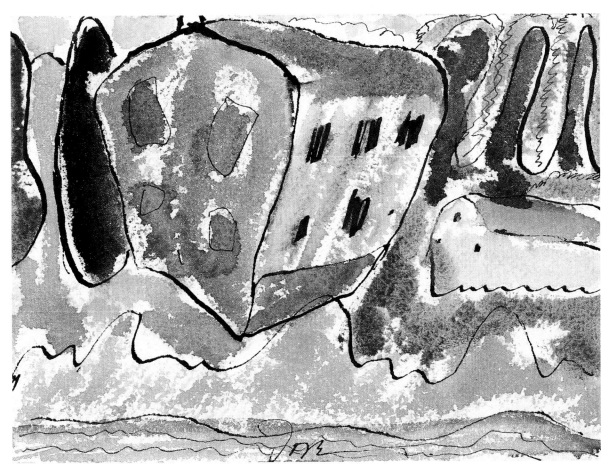

Plate 18

Houses on the Shore

1935, watercolor on paper, 5 x 7 in.
Carnegie Museum of Art, Pittsburgh

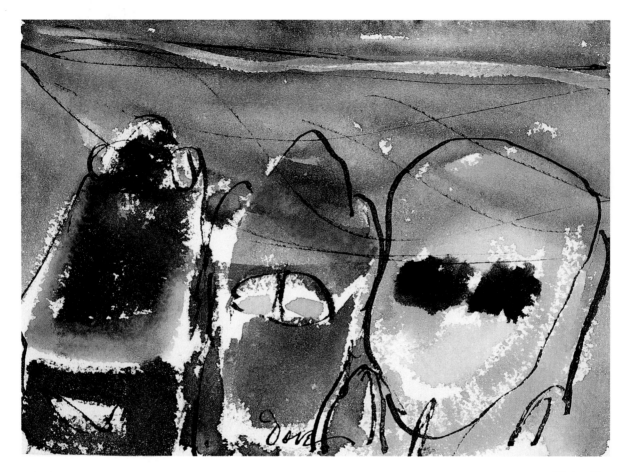

Plate 19

Cars in a Sleet Storm

1938, watercolor on paper, 5 x 7 in.
Herbert F. Johnson Museum of Art,
Cornell University, Ithaca, New York

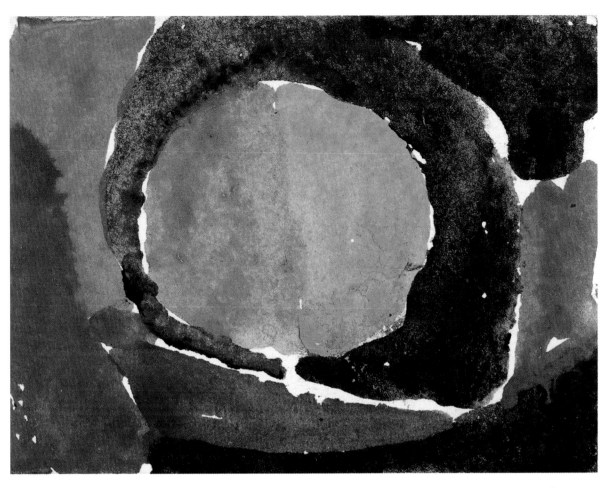

Plate 20

Untitled Sketch

c. 1940–46, watercolor on paper, 3 x 4 in.
Amon Carter Museum, Fort Worth, Texas

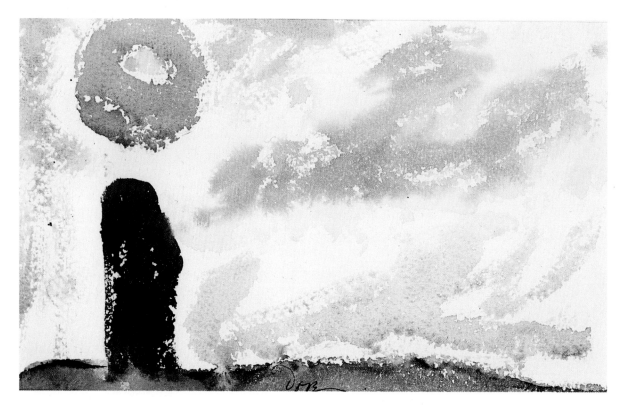

Plate 21

Brown Sun and Housetop

1937, watercolor on paper, 5 ½ x 9 in.
Brauer Museum of Art, Valparaiso University, Indiana

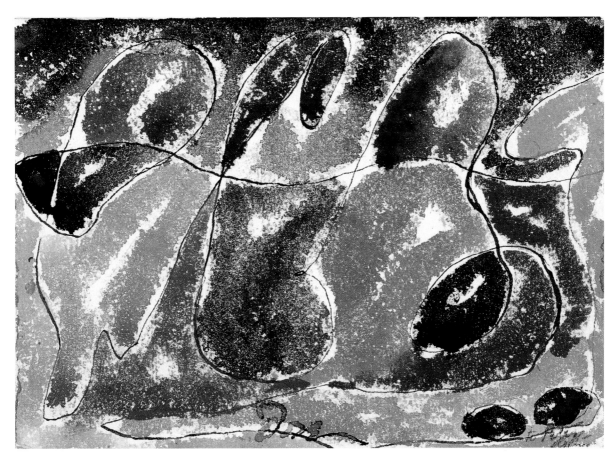

Plate 22

Abstraction, Autumn Leaves

1938, watercolor and pen and black ink on paper
laid down on board, 4 7/8 x 6 7/8 in. Christie's Images, New York

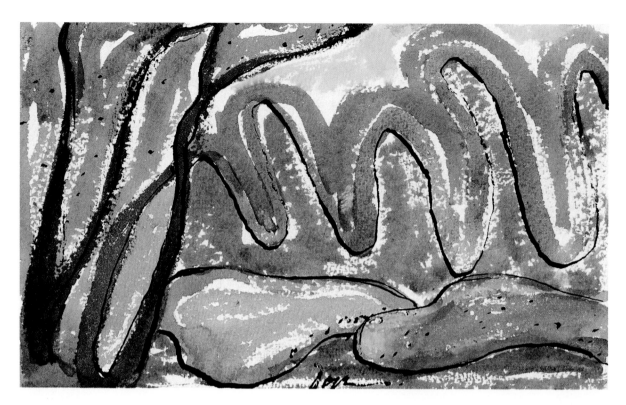

Plate 23

Canandaigua Outlet, Oaks Corner

1937, watercolor on paper mounted on board, 5 ½ x 9 in.
Carnegie Museum of Art, Pittsburgh

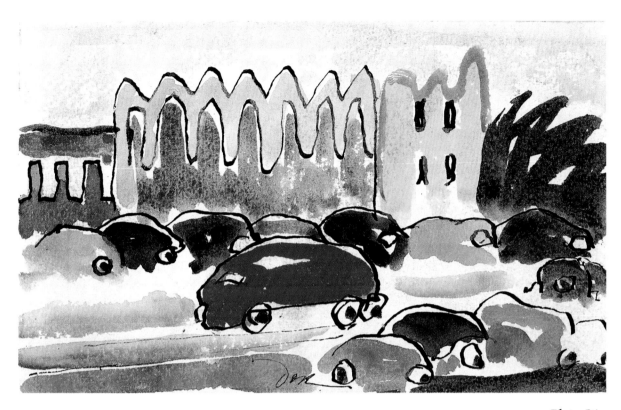

Plate 24

Exchange Street, Geneva

1938, pen, ink, and watercolor on paper, 5 ½ x 9 in.
Amon Carter Museum, Fort Worth, Texas

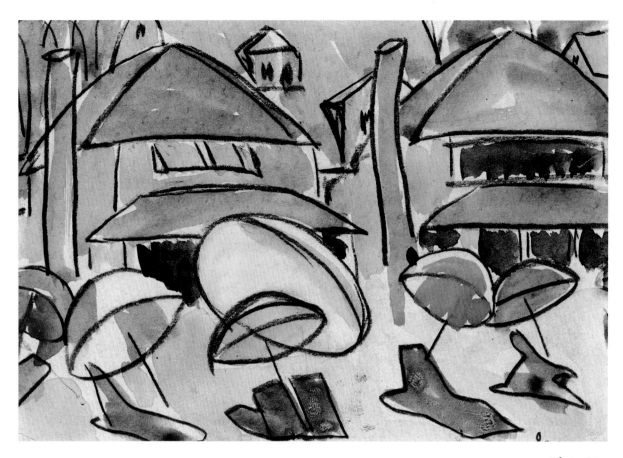

Plate 25

Beach Umbrellas

1931, watercolor and charcoal on paper, 4 3/4 x 6 7/8 in.
Christie's Images, New York

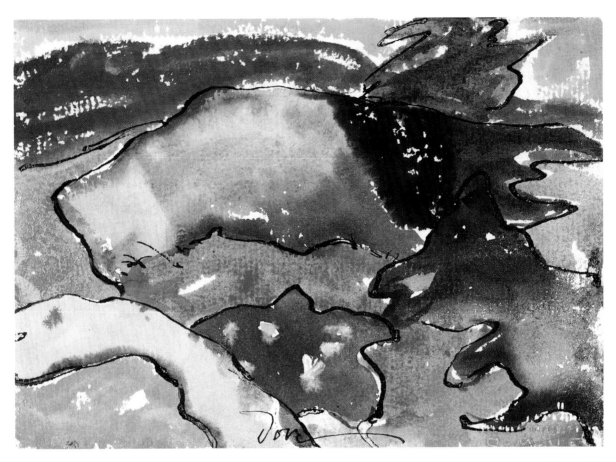

Plate 26

From Cows

1937, watercolor, pen, and black ink on wove paper, 5 x 7 in.
National Gallery of Art, Washington D.C.

Boat

1932, watercolor and
charcoal on paper,
8 1/4 x 10 3/4 in.
Heckscher Museum,
Huntington, New York

102

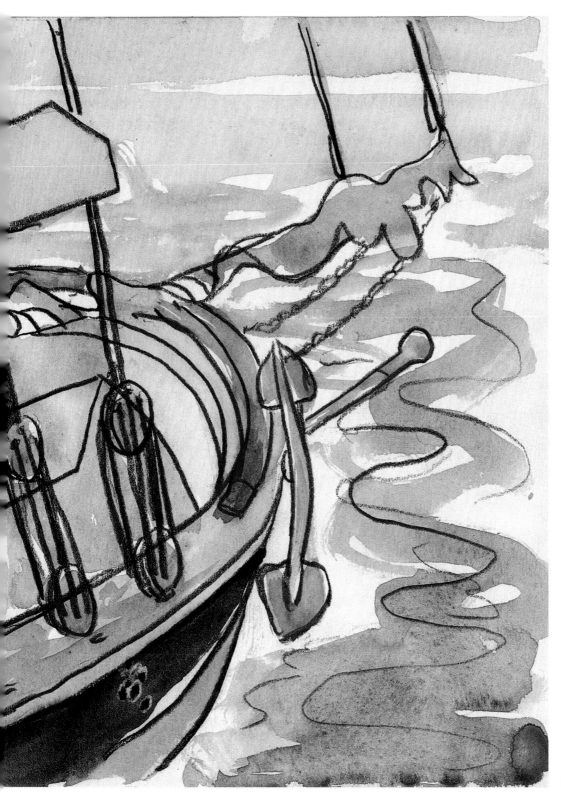

Plate 27

Plate 28

A Barn Here and a Tree There

1940, watercolor on paper mounted on board, 4⅞ x 6⅞ in.
Carnegie Museum of Art, Pittsburgh

opposite:

Flour Mill II

1938, watercolor on paper, 9 x 7 in.
Wadsworth Atheneum, Hartford, Connecticut

Plate 29

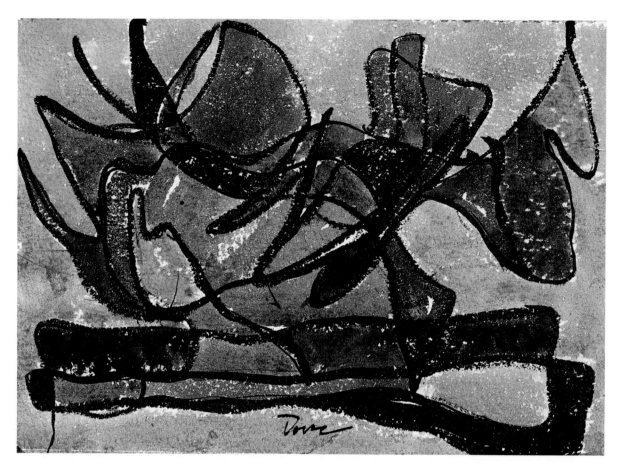

Plate 30

Untitled 1, Centerport

c. 1940, watercolor on paper, 5 x 7 in.
The Georgia Museum of Art, Athens

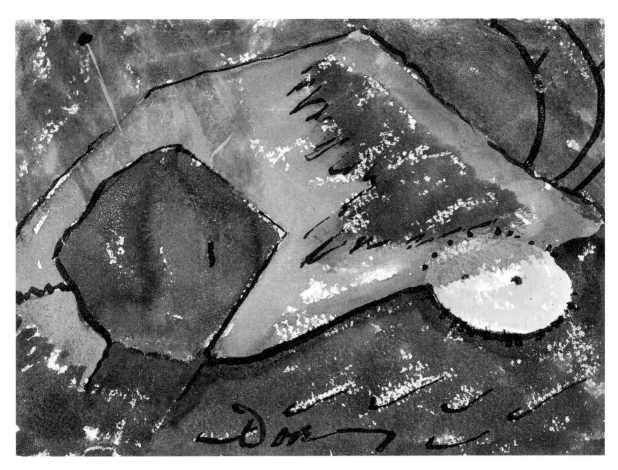

Plate 31

No Feather Pillow

1940, watercolor on wove paper, 5 x 7 in.
Herbert F. Johnson Museum of Art,
Cornell University, Ithaca, New York

The Hand Sewing Machine

1941, watercolor on paper, 7 x 5 in.
Herbert F. Johnson Museum of Art,
Cornell University, Ithaca, New York

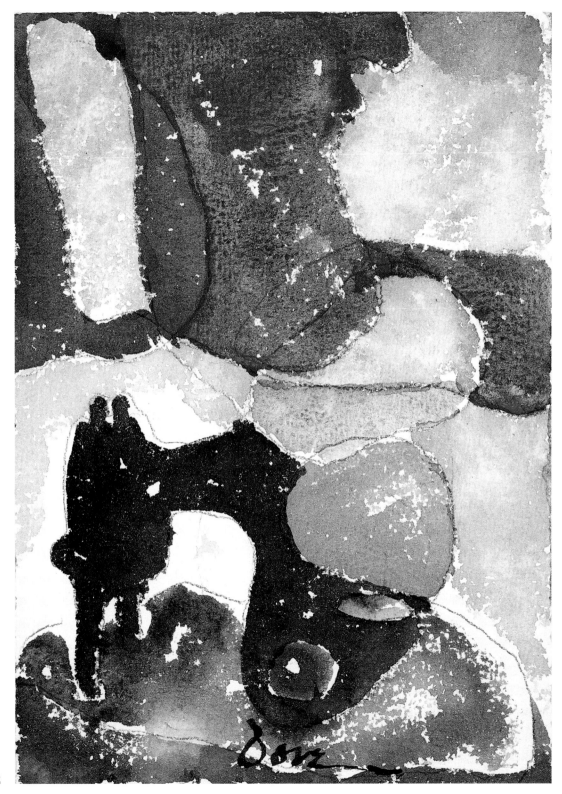

Plate 32

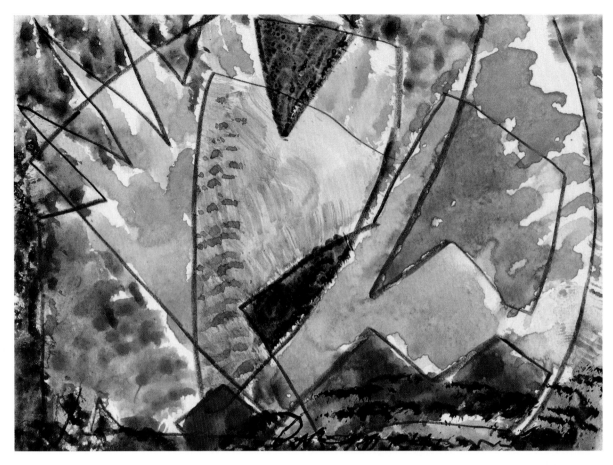

Plate 33

Untitled Centerport #2

1941, watercolor and pencil on paper, 4 x 5 ½ in.
Heckscher Museum, Huntington, New York

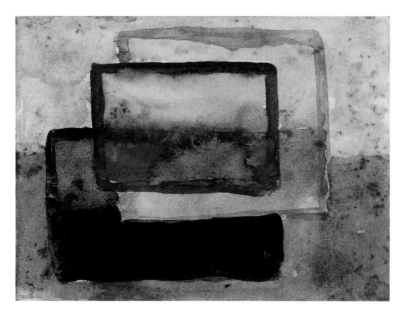

Plate 34

Untitled from Sketchbook "E"
(Red, green, and blue rectangles)

c. 1940–46, watercolor on paper, 3 x 4 in.
The Arkansas Arts Center Foundation Collection,
Little Rock

Selected Bibliography

ARCHIVES

Arthur and Helen Torr Dove Papers, Archives of American Art; microfilm reels N70/51–N70/52, 38–40, 725, 954, 1150, 2803, and 4681–4682.

Suzanne Mullett Smith Papers, Archives of American Art; microfilm reels 1043 and 2425–2426.

PUBLISHED SOURCES

Andrew Crispo Gallery. *Ten Americans: Avery, Burchfield, Demuth, Dove, Homer, Hopper, Marin, Prendergast, Sargent, Wyeth*. May 16–June 30. New York, 1974.

Baigell, Matthew. "American Art and National Identity: the 1920s," *Arts Magazine* 61 (Feb. 1987): 48–55.

Bolger, Doreen, et al. *American Pastels in the Metropolitan Museum of Art*. New York: The Metropolitan Museum of Art, 1989.

Bricker Balken, Debra; William C. Agee; and Elizabeth Hutton Turner. *Arthur Dove: A Retrospective*. Cambridge, Mass.: The MIT Press, 1997.

Cassidy Donna M. "Arthur Dove's Music Paintings of the Jazz Age," *American Art Journal 20*, no. 1 (1988): 5–23.

Cohn, Sherrye. *Arthur Dove: Nature as Symbol*. Ann Arbor, Mich.: UMI Research Press, 1985.

Curry, Larry. *Eight American Masters of Watercolor: Winslow Homer, John Singer Sargent, Maurice B. Prendergast, John Marin, Arthur G. Dove, Charles Demuth, Charles E. Burchfield, Andrew Wyeth*. New York: The Los Angeles County Museum of Art and Frederick A. Praeger, Publishers, 1968.

DePietro, Anne Cohen, et al. *Arthur Dove & Helen Torr: The Huntington Years*. Huntington, N.Y.: The Heckscher Museum, 1989.

Eldredge, Charles C. *Reflections on Nature: Small Paintings by Arthur Dove 1942–1943*. New York: The American Federation of Arts, 1997.

Finch, Christopher. *Twentieth-Century Watercolors*. New York: Abbeville Press, 1988.

Gallati, Barbara Dayer. "The American Watercolor in the 1920s," *The Magazine·Antiques* 153, no. 3 (March 1998): 448–457.

Haskell, Barbara. *Arthur Dove*. San Francisco: San Francisco Museum of Art, 1974.

Homer, William Innes. "Identifying Arthur Dove's 'The Ten Commandments'," *American Art Journal* 12, no. 3 (Summer 1980): 21–32.

Howat, John K.; Victor Koshkin-Youritzin; and Stephen Rubin. *American Watercolors from the Metropolitan Museum of Art*. New York: The American Federation of Arts in association with Harry N. Abrams, Inc., Publishers, 1991.

Johnson, Dorothy R. *Arthur Dove: The Years of Collage*. College Park, Md.: University of Maryland Art Gallery, 1967.

Kushner, Marilyn. *The Modernist Tradition in American Watercolors 1911–1939*. Evanston, Ill.: Mary and Leigh Block Gallery, Northwestern University, 1991.

McCausland, Elizabeth. "Dove: Man and Painter," *Parnassus* (December 1937): 3–6.

Morgan, Ann Lee, ed. *Arthur Dove: Life and Work, With a Catalogue Raisonné*. Newark, Del.: University of Delaware Press, 1984.

———. *Dear Stieglitz, Dear Dove*. Newark, Del.: University of Delaware Press, 1988.

Museum of Fine Arts, Museum of New Mexico, Santa Fe. *Georgia O'Keeffe: Works on Paper*. Introduction by David Turner. Essay by Barbara Haskell. Santa Fe: Museum of New Mexico Press, 1985.

Newman, Sasha M. *Arthur Dove and Duncan Phillips: Artist and Patron*. Washington D.C.: The Phillips Collection in association with George Braziller, Inc., New York, 1981.

Reed, Sue Welsh, and Carol Troyen. *Awash in Color: Homer, Sargent, and the Great American Watercolor*. Boston: Museum of Fine Arts, Boston, in association with Bulfinch Press, Little, Brown and Company, 1993.

Stebbins, Theodore E., Jr. *American Master Drawings and Watercolors*. New York: Harper & Row, Publishers, 1976.

Syracuse University. *Arthur Dove Watercolors*. Exhibition pamphlet. New York, N.Y.: (December 19, 1972–January 19, 1973). Arthur and Helen Torr Dove Papers, Archives of American Art; microfilm reel 4682, frames 877–879.

Thompson, Jan. "Picabia and His Influence on American Art, 1913–17," *Art Journal* 39 (Fall 1979): 14–21.

Wight, Frederick S. *Arthur G. Dove*. Berkeley and Los Angeles: University of California Press, 1958.

Yeh, Susan Fillin. "Innovative Moderns: Arthur G. Dove and Georgia O'Keeffe," *Arts Magazine* 56 (June 1982): 68–72.

Zilczer, Judith. "Synaesthesia and Popular Culture: Arthur Dove, George Gershwin, and the 'Rhapsody in Blue'," *Art Journal* (Winter 1984): 361–65.

List of Illustrations

BLACK AND WHITE:

Figure 1. (*page 10*)
Alfred Stieglitz.
Arthur G. Dove.
1922, Gelatin-silver print, 9 $^3/_8$ x 7 $^1/_2$ in.
Philadelphia Museum of Art, Collection of
Dorothy Norman, 1967-285-49.

Figure 2. (*page 17*)
Arthur Dove.
After the Storm, Silver and Green (Vault Sky). c.
1923, oil and metallic paint on wood panel,
24 x 18 in. New Jersey State Museum,
Trenton, Gift of Mr. and Mrs. L. B. Wescott,
A74.75. Photo: Joseph Crilley.

Figure 3. (*page 27*)
John Marin.
Lower Manhattan.
1920, watercolor and charcoal on paper,
21 $^7/_8$ x 26 $^3/_4$ in. Museum of Modern Art, New
York, The Philip L. Goodwin Collection.
Photograph © The Museum of Modern Art,
New York.

Figure 4. (*page 47*)
Georgia O'Keeffe.
Blue No. 1.
1916, watercolor on tissue paper, 16 x 11 in.
The Brooklyn Museum of Art, New York,
Bequest of Mary T. Cockcroft, 58.73.

Figure 5. (*page 50*)
Arthur Dove.
Swinging in the Park.
1930, watercolor, 4 $^5/_8$ x 6 $^3/_4$ in. Colby
College Museum of Art, Waterville, Maine,
Bequest of Adelaide Moise, 1986.26.

Figure 6. (*page 61*)
Arthur Dove.
Untitled from Sketchbook "E."
c. 1940–46, graphite and colored pencil
on machine-made wove paper, 3 x 4 $^1/_{16}$ in.
The Arkansas Arts Center Foundation
Collection, Little Rock, Gift of William C.
Dove, 1992.55.2.

COLOR PLATES (ALL BY ARTHUR DOVE):

Frontispiece. (*page 2*)
Centerport Series, No. 4.
1941–42, watercolor on paper, 5 x 7 in.
Herbert F. Johnson Museum of Art, Cornell
University, Ithaca, New York, Dr. and Mrs.
Milton Lurie Kramer (Class of 1936)
Collection, Bequest of Helen Kroll Kramer,
72.110.004.

Plate 1. (*page 73*)
Movement No. 1.
c. 1911, pastel on canvas, 21 $^3/_8$ x 18 in.
Columbus Museum of Art, Ohio, Gift of
Ferdinand Howald.

Plate 2. (*page 74*)
Team of Horses.
1911 or 1912, pastel on composition board,
18 1/8 x 21 1/2 in. Amon Carter Museum,
Fort Worth, Texas, 1984.29.

Plate 3. (*page 75*)
Sails.
1911–12, pastel on composition board
mounted on panel, 17 7/8 x 21 1/2 in.
Terra Foundation for the Arts, Chicago,
Daniel J. Terra Collection, 1993.10.

Plate 4. (*page 77*)
Sentimental Music.
1917, pastel on gray paper, mounted on
plywood, 21 1/4 x 17 7/8 in. The Metropolitan
Museum of Art, New York, Alfred Stieglitz
Collection, 1949 (49.70.77).

Plate 5. (*page 78*)
Cow.
c. 1911, pastel on linen, 18 x 20 5/8 in.
The Metropolitan Museum of Art, New York,
Alfred Stieglitz Collection, 1949 (49.70.72).

Plate 6. (*page 79*)
Distraction.
1928, brush and black ink and watercolor,
8 9/16 x 12 1/8 in. National Gallery of Art,
Washington, D.C., Ailsa Mellon Bruce Fund,
1973.42.1 (DR). Photo: Dean Beasom.

Plate 7. (*page 80*)
Untitled Sketch (Study for Green and Brown).
1945, oil, watercolor, and ink on paper,
3 x 4 in. Amon Carter Museum, Fort Worth,
Texas, Gift of William G. Dove, 1987.46.

Plate 8. (*page 81*)
Swinging in the Park.
1930, watercolor, 4 5/8 x 6 3/4 in. Colby College
Museum of Art, Waterville, Maine, Bequest
of Adelaide Moise, 1986.26.

Plate 9. (*page 82*)
Untitled.
no date, watercolor and ink on paper,
5 x 6 3/4 in. Collection of Mr. and Mrs. John
B. Rehm. Photo: Lee Stalsworth.

Plate 10. (*page 83*)
Barns.
1935, watercolor on paper mounted on
cardboard, 5 1/16 x 7 in. Carnegie Museum of
Art, Pittsburgh, Bequest of Mr. and Mrs.
James H. Beal, 93.189.29.

Plate 11. (*page 84*)
Out of the Window.
1940, watercolor on paper, 5 x 7 in.
Sheldon Memorial Art Gallery, University
of Nebraska-Lincoln, Howard S. Wilson
Memorial, 1982.U-3115. Photo: John Spence.

Plate 12. (*page 85*)
Arrangement from Landscape.
1941, gouache and ink on paper, 5 x 7 in.
Heckscher Museum, Huntington, New York,
Gift of Mr. William C. Dove, 1977.1.5.
Photo: Jim Strong, Inc.

Plate 13. (*pages 86–87*)
Plant Forms.
c. 1912, pastel on canvas, 17 1/4 x 23 7/8 in.
Whitney Museum of American Art, New
York, Purchase, with funds from Mr. and Mrs.
Roy R. Neuberger, 51.20. Photo: Geoffrey
Clements. Photograph © 1998: Whitney
Museum of American Art, New York.

Plate 14. (*page 88*)
Sunrise.
1937, watercolor on paper, 5 x 7 in.
Wadsworth Atheneum, Hartford,
Connecticut, The Ella Gallup Sumner and
Mary Catlin Sumner Collection Fund,
1955.265.

Plate 15. (*page 89*)
Tree Forms.
1928, pastel on wood, 26 x 31 in. Carnegie Museum of Art, Pittsburgh, Gift of Mr. and Mrs. James H. Beal, 60.3.2.

Plate 16. (*pages 90–91*)
Yachting.
c. 1912, pastel on canvas, 18 x 21 $^1/_2$ in. Museum of Fine Arts, Boston, Gift of the William H. Lane Foundation, 1990.400.

Plate 17. (*page 92*)
Falling Shed Roof.
1934, watercolor on paper mounted on board, 4 $^7/_8$ x 6 $^7/_8$ in. Carnegie Museum of Art, Pittsburgh, Bequest of Mr. and Mrs. James H. Beal, 93.189.27.

Plate 18. (*page 93*)
Houses on the Shore.
1935, watercolor on paper, 5 x 7 in. Carnegie Museum of Art, Pittsburgh, Gift of Sara M. Winokur and James L. Winokur in honor of the Sarah Scaife Gallery, 72.50.1. Photo: Richard Stoner.

Plate 19. (*page 94*)
Cars in a Sleet Storm.
1938, watercolor on paper, 5 x 7 in. Herbert F. Johnson Museum of Art, Cornell University, Ithaca, New York, Gift of the Museum Membership Fund, 54.074.

Plate 20. (*page 95*)
Untitled Sketch.
c. 1940–46, watercolor on paper, 3 x 4 in. Amon Carter Museum, Fort Worth, Texas, Gift of William G. Dove, 1984.50.

Plate 21. (*page 96*)
Brown Sun and Housetop.
1937, watercolor on paper, 5 $^1/_2$ x 9 in. Brauer Museum of Art, Valparaiso University, Indiana, Gift of Josephine and Byron Ferguson in appreciation of Richard Brauer.

Plate 22. (*page 97*)
Abstraction, Autumn Leaves.
1938, watercolor and pen and black ink on paper laid down on board, 4 $^7/_8$ x 6 $^7/_8$ in. Christie's Images, New York.

Plate 23. (*page 98*)
Canandaigua Outlet, Oaks Corner.
1937, watercolor on paper mounted on board, 5 $^1/_2$ x 9 in. Carnegie Museum of Art, Pittsburgh, Bequest of Mr. and Mrs. James H. Beal, 93.189.26.

Plate 24. (*page 99*)
Exchange Street, Geneva.
1938, pen, ink, and watercolor on paper, 5 $^1/_2$ x 9 in. Amon Carter Museum, Fort Worth, Texas, 1982.57.

Plate 25. (*page 100*)
Beach Umbrellas.
1931, watercolor and charcoal on paper, 4 $^3/_4$ x 6 $^7/_8$ in. Christie's Images, New York.

Plate 26. (*page 101*)
From Cows.
1937, watercolor, pen, and black ink on wove paper, 5 x 7 in. National Gallery of Art, Washington D.C., Gift of Mr. and Mrs. William C. Janss, in honor of the 50th anniversary of the National Gallery of Art, 1991.224.1 (DR). Photo: Dean Beasom.

Plate 27. (*pages 102–103*)
Boat.
1932, watercolor and charcoal on paper, 8 $^1/_4$ x 10 $^3/_4$ in. Heckscher Museum, Huntington, New York, Museum purchase, 1997.1.5. Photo: Jim Strong, Inc.

Plate 28. (*page 104*)
A Barn Here and a Tree There.
1940, watercolor on paper mounted on
board, 4 7/8 x 6 7/8 in. Carnegie Museum of
Art, Pittsburgh, Bequest of Mr. and Mrs.
James H. Beal, 93.189.28.

Plate 29. (*page 105*)
Flour Mill II.
1938, watercolor on paper, 9 x 7 in.
Wadsworth Atheneum, Hartford,
Connecticut, The Ella Gallup Sumner
and Mary Catlin Sumner Collection Fund,
1955.264.

Plate 30. (*page 106*)
Untitled 1, Centerport.
c. 1940, watercolor on paper, 5 x 7 in. The
Georgia Museum of Art, Athens, Gift of A. H.
Holbrook, 68.2227. Photo: Michale McKelvey.

Plate 31. (*page 107*)
No Feather Pillow.
1940, watercolor on wove paper, 5 x 7 in.
Herbert F. Johnson Museum of Art, Cornell
University, Ithaca, New York, Dr. and Mrs.

Milton Lurie Kramer (Class of 1936)
Collection, Bequest of Helen Kroll Kramer,
72.110.005.

Plate 32. (*page 109*)
The Hand Sewing Machine.
1941, watercolor on paper, 7 x 5 in.
Herbert F. Johnson Museum of Art, Cornell
University, Ithaca, New York, Gift of Mr. and
Mrs. Morris G. Bishop, 54.073.

Plate 33. (*page 110*)
Untitled Centerport #2.
1941, watercolor and pencil on paper,
4 x 5 1/2 in. Heckscher Museum, Huntington,
New York, Gift of William C. Dove, 1977.1.2.
Photo: Jim Strong, Inc.

Plate 34. (*page 111*)
Untitled from Sketchbook "E"
(Red, green, and blue rectangles).
c. 1940–46, watercolor on paper, 3 x 4 in.
The Arkansas Arts Center Foundation
Collection, Little Rock, Gift of William C.
Dove, 1992.55.7.